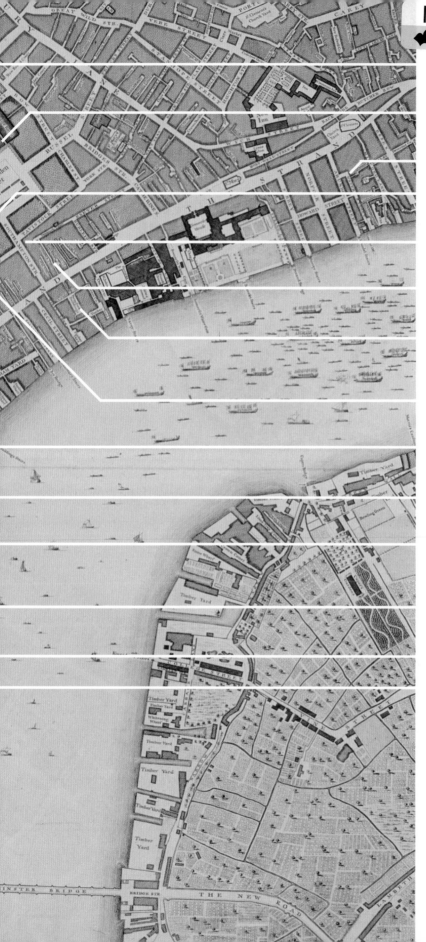

1. Turk's Head Tavern, Gerrard Street

2. Piazza Coffee House, Covent Garden

3. Greyhound Court

4. Rathmell's Coffee House, Henrietta Street

5. Bedford Head Tavern, Southampton Street

6. Society of Arts, Little Denmark Court

7. William Shipley's drawing school, Beaufort's Buildings, Strand

8. Munday's Coffee House, Maiden Lane

9. Joshua Reynolds's house, Leicester Fields

10. Cock's Auction Rooms, Spring Gardens

11. William Hunter's house and anatomy theatre, Great Windmill Street

12. Lambe's Auction Rooms, Pall Mall

13. St James's Palace

14. The Duke of Richmond's drawing school, Privy Garden, Whitehall

John Rocque's Survey of London, 1746. A Plan of the Cities of London and Westminster, and Borough of Southwark, 1746 (detail). Engraving. London Metropolitan Archives, London

The Company of Artists

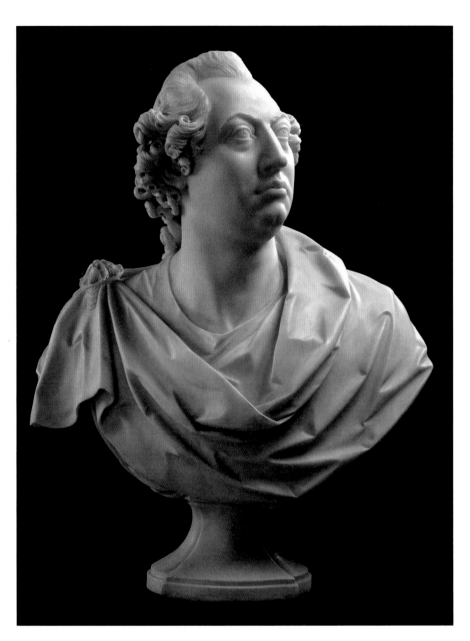

Agostino Carlini, *Bust of George III*, 1773

Charles Saumarez Smith

The Company of Artists

The Origins of
the Royal Academy of Arts
in London

Modern Art Press
in association with Bloomsbury

For John & Sally

First published in Great Britain in 2012 by Modern Art Press Ltd,
4th Floor, 3 Duke of York Street, London SW1Y 6JP

British Library Cataloguing-in-Publication Data
A catalogue record for this book is available from the British Library

ISBN 978-1-408182-10-9 (hardback)

Distributed worldwide by Bloomsbury Publishing

Designed by Derek Birdsall RDI
Typeset in Founders Caslon Old Face by Shirley and Elsa Birdsall
Production supervision by Martin Lee Associates
Colour origination by DawkinsColour
Printed by Printer Trento Srl, Italy

Contents

Acknowledgements

I began to sketch out the ideas in this book in preparation for my inaugural lecture as a visiting professor at Queen Mary, University of London, and I am grateful to Queen Mary, and particularly Professor Lisa Jardine, for their support, as well as to those people who have invited me to talk about aspects of the history of the Royal Academy since, including the Royal Academy Schools, the Reynolds Club, Professor Gerald Libby, the Art Worker's Guild, and Hannah Malone, who asked me to speak at a postgraduate seminar in Cambridge.

During the writing of these lectures, I have been constantly indebted to Mark Pomeroy, Archivist of the Royal Academy, for answering endless questions, and to Nicholas Savage, the Academy's Head of Collections and Library, for providing detailed comments on my texts. Both read the final manuscript and saved me from many errors. I have also been helped by Adam Waterton, the Academy's Head of Library Services, in the pursuit of rare books and periodical articles.

My two sons, Otto and Ferdinand, and Lucian Robinson all gave very helpful advice at a critical juncture, encouraging me to look beyond issues of personality to the underlying ideas, and my wife, Romilly, encouraged me to read parts of the text to her in order to clarify it.

Since completing the first draft, I have had help on specific issues from a number of people, including Frank Albo and Harriet Sandvall on Freemasonry; Susan Snell, Archivist at Freemasons' Hall; John Brewer on Edmund Burke; Edward Chaney and Frances

Harris on John Evelyn; William Nicholson, who helped with a discussion of issues of narrative over breakfast at Barcombe; and Margaret Powell, Librarian of the Lewis Walpole Library in Farmington, Connecticut, who provided photocopies of Horace Walpole's comments on the early Annual Exhibition catalogues.

A number of friends and colleagues have generously agreed to read and provide comments on versions of the draft, including Brian Allen, Professor Clare Brant, Loyd Grossman, Matthew Hargraves, Christopher Le Brun PRA, Sir Alan Moses, Rebecca Nicolson, Marc Pachter, and Jenny Uglow. It was thanks to Sir Christopher Ondaatje that I was introduced to Jamie Camplin, who gave invaluable advice on content and structure. I am greatly indebted to him; to my literary agent Maggie Hanbury; and, above all, to John Morton Morris, who arranged for the book's publication by Toby Treves of Modern Art Press.

I am grateful to Emma-Louise Hunt, who secured the pictures; Peter Sawbridge, for his meticulous editing; and Derek Birdsall, for his brilliant typographic design. Toby Treves nursed the book through the birth-pangs of its production and Nigel Newton and Robin Baird-Smith arranged for its distribution by Bloomsbury.

Finally, it will be evident that much of my interest in the early history of the Royal Academy is derived from my experience of working there. So, I close by expressing my gratitude to the members of Council who appointed me and, most especially, to Sir Nicholas Grimshaw PPRA and Christopher Le Brun PRA, for their friendship and moral support.

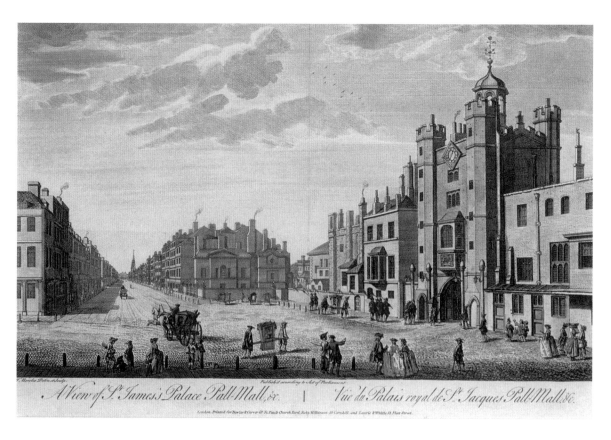

A View of St James's Palace Pall-Mall, &c. Vüe du Palais royal de St Jacques Pall-Mall, &c.

1. Thomas Bowles, *A View of St James's Palace, Pall Mall*, published 1753

Prologue

Some time in the cold, damp, windy afternoon of Monday 28 November 1768, four figures arrived at the gateway of St James's Palace (plate 1; map key 13) to see King George III. The monarch was engaged for most of the afternoon in a ceremony in which, according to the *London Gazette*, he 'was pleased to invest the Duke of Roxburgh with the Ensigns of the most Ancient and most Noble Order of the Thistle'. But, afterwards, he had agreed to see a small group of artists, including an architect, two of whom he knew quite well.

The first of these was the architect, William Chambers (plate 2), who, a decade before, had taught the King, when he was Prince of Wales, how to draw. Chambers, now forty-five, was hard-working, conscientious and independent-minded. Born in Sweden, he had travelled the world as a merchant, and returned from China to be trained as an architect at the Ecole des Arts in Paris. In the late 1750s, he had talked to the King about the idea of establishing an academy, equivalent to those that he had experienced in France and Italy, in order to improve the practice of art, and, more especially, architecture in Great Britain.

The King knew that this was why Chambers was coming to see him, because he had heard rumblings about the break-up of the Society of Artists from his librarian, Richard Dalton, and indeed, he had already had a private conversation with Chambers in which he had said that he would be more than willing to give his name to an academy. George was interested in the arts and wanted to encourage history painting and its status in his realm.

Chambers was accompanied by Benjamin West (plate 3), aged thirty, a slightly cocky American painter, whom the King had recently got to know, again through the good offices of his librarian Richard Dalton. The King admired West's work, which was ambitious, its subject-matter often based on classical mythology, with a strong sense of narrative. West believed passionately that painting

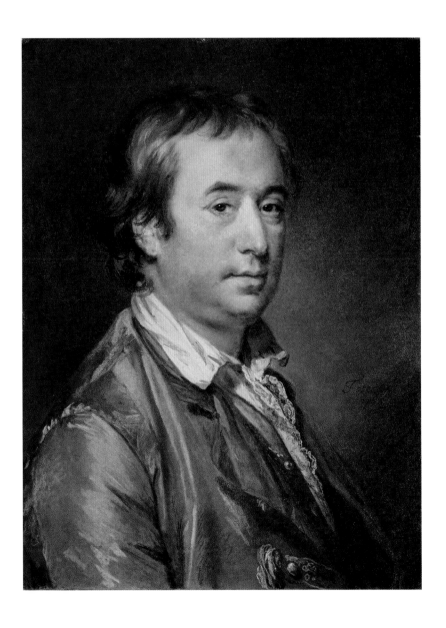

should be about more than just portraiture and could, and should, have moral and didactic content. This belief lay at the heart of the idea of an academy. The King was sufficiently sympathetic to West's cause to have recently commissioned him to paint a big, historical picture for his private apartments at Buckingham House entitled *The Departure of Regulus from Rome*.

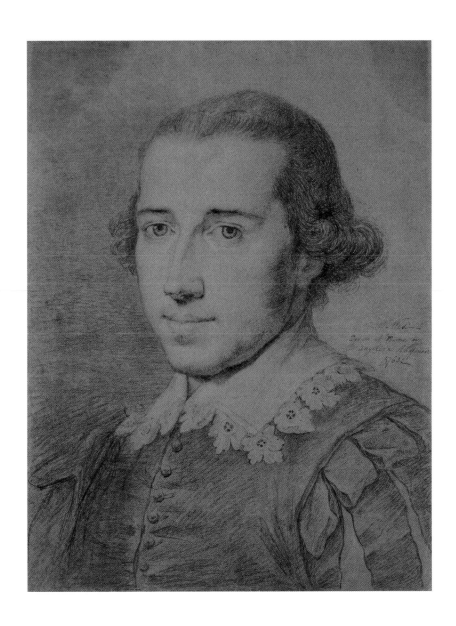

2. Francis Cotes,
William Chambers, 1764

3. Angelica Kauffman,
Benjamin West, 1763

The third artist was older, at sixty-two, and Swiss. George Michael Moser (plate 4) had for years been trying to establish an academy in London, beginning not long after he first arrived as an *emigré* in 1726. By 1736 he had established what was described by his daughter Mary as 'a little Academy for drawing from a living model by lamp light' in Greyhound Court, off Arundel Street, just east of old Somerset House (map key 3). Moser was a pillar of the St Martin's Lane Academy, acting as its Treasurer and Manager, and, in the 1750s, he had made strenuous efforts to establish an academy under the auspices of the Society of Arts, even to the extent of writing out what its rules should be. He wanted proper facilities for teaching students, not just for the purpose of improving the practice of

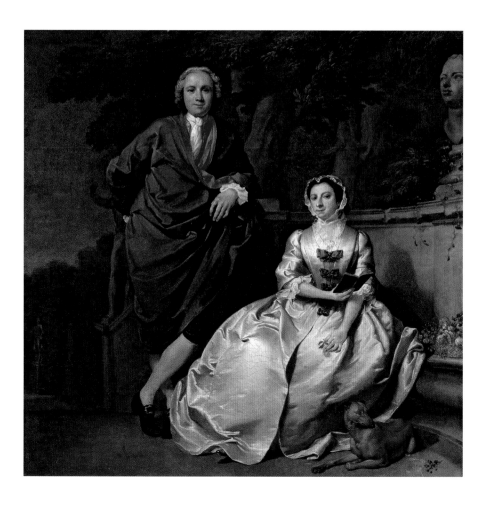

painting, but also so that the many artisans around Soho and Covent Garden might have an opportunity to improve and promote their trade.

The fourth member of Chambers's deputation was a forty-two-year-old painter called Francis Cotes (plate 5), a nice, decent artist who had made money painting tender and sentimental portraits of the peerage, as well as of the Queen and her children. The previous year he had painted Queen Charlotte and her daughter, a portrait that had been much admired by Horace Walpole when exhibited at the annual exhibition of the Society of Artists. Cotes was presumably there because his work was well regarded by the royal family, and thus he lent respectability to the group.

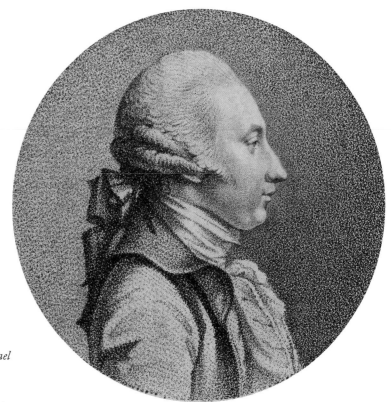

4. Carl Marcus Tuscher, *George Michael Moser and His Wife Mary*, *c.* 1741–3

5. D. P. Pariset after Pierre-Etienne Falconet, *Portrait of Francis Cotes*, 1768

We don't have any record of the conversation that afternoon. No records were kept. But we do know a great deal about the historical circumstances that led these artists to seek an audience with the King, about the ideas and beliefs that inspired them, and about the likely content of their conversation.

Since becoming Secretary and Chief Executive of the Royal Academy in 2007, I have become intensely interested in what was said that afternoon. The discussion led, less than two weeks later, to the establishment of the Royal Academy of Arts, when twenty-eight artists returned to St James's Palace for a ceremony to mark its foundation. They came with a so-called Instrument of Foundation, which included most of the rules by which the Academy still operates. What inspired them? How was it that everything happened so quickly?

I wrote this book to find out. It is a historiographical experiment, in which I have attempted to bring the Academy's origins to life through close description and, as far as possible, a day-by-day narrative of events in the months leading up to, and immediately following, its foundation. I wanted to discover the truth about why the Royal Academy was founded, the interaction of the group of artists and architects who established it, why they broke away from the Society of Artists, which had previously shown signs of doing exactly what the Royal Academy was established to do, and what they thought and felt when they met King George III for him to sign the Instrument of Foundation on Saturday 10 December 1768. I have tried to enter into the mind-set of those who originally established the Royal Academy, while recognising that this is never going to be wholly possible, by telling the story as accurately as I can of how the institution came into being.

I *Background*

In order to understand why the Royal Academy was founded in the late 1760s, it is essential to have some knowledge of the many artists' societies and associations that had been established in London in the first half of the eighteenth century, why they failed, and the way in which the establishment of the Royal Academy itself in 1768 represented a merger of previously existing aspirations stretching back at least a century. For this was by no means the first attempt to establish an organisation in Britain to represent the professional interests of artists, to provide facilities for the teaching of the next generation, and to provide an opportunity for the public to see an exhibition of contemporary works of art. Nor was this even the first attempt to establish an organisation that described itself as an academy.

The origins of the Royal Academy lie in the various academies established in the Italian city-states of the fifteenth and sixteenth centuries: in the world of humanist learning when Ghiberti and Alberti first promoted the idea that skill in *disegno* was a necessary foundation for the practice of art; and when the word *accademia* was used as the word to describe a place of retreat and contemplation, as when the humanist scholar Poggio Bracciolini described his villa outside Florence as 'my "Academy" in Val d'Arno'.

Leonardo da Vinci is said to have established an 'Academia Leonardi Vincii' at the end of the fifteenth century in Milan, but there is no record of what was taught. The presumption must be that its establishment was closely connected to Leonardo's well-recorded view that painting should be treated as a liberal art, not just as a craft, and that painters would benefit from a rigorous training in drawing and perspective.

The best-known sixteenth-century academy was Vasari's Accademia del Disegno in Florence, which was given a formal constitution in 1563 under the patronage of Cosimo de' Medici and which may owe its origins to an earlier academy set up in the Tuscan capital by Lorenzo de' Medici to train artists and, most especially, sculptors in drawing from the antique. Vasari's academy was certainly derived from discussions surrounding the establishment of the Accademia Fiorentina in 1542 and from the belief that the liberal arts of painting, sculpture and architecture should be studied and taught alongside their sister arts of rhetoric, poetry and logic. Vasari's regulations enshrined strict requirements for the training of artists, based on his belief, evident in his *Lives of the Artists*, that *disegno* was the key to all the arts. His artists were to study arithmetic, geometry and anatomy as well as drawing.

A decade or so later, Federico Zuccaro helped to clarify the appropriate requirements for an artist's course of study, which he felt should be based on a good knowledge of mathematics and include a rigorous programme of life drawing for which prizes would be awarded. The idea of an academy was beginning to crystallise around a belief in a system of training that was planned to be at least as much intellectual as artistic. It was Zuccaro, who, in 1593, was involved in establishing the Accademia di San Luca in Rome, named after the patron saint of painting. First announced by papal decree in 1577 and still in existence today, the Accademia di San Luca was almost certainly the most influential of the European art academies. In spite of being relatively moribund in the mid-eighteenth century,

it provided some of the core beliefs behind the establishment of the Royal Academy in London: the idea that the practice of art would benefit from regular discussion and debate concerning its character, as well as more theoretical analysis of its principles; a roster of visiting teachers, one a month, who were to decide whether or not a student should move from drawing casts to drawing from the life; and the award of prizes for the best students. These components existed in all the academies that were founded in Italy, the Netherlands and France in the late sixteenth and seventeenth centuries: in Perugia in 1573, in Bologna under the Carracci in 1582, in Haarlem in 1600, in Modena in 1637, and, most importantly, the Académie Royale de Peinture et de Sculpture under the patronage of the Crown in Paris in 1648.

What one finds in these discussions surrounding the idea of an academy is a close relationship between the arts and broader issues of study, training, teaching and learning. It is no accident that the word academy in its modern usage applies to a great range of institutions of public learning, because the fundamental ideas behind academies, concerning the codification of intellectual practices, the professionalisation of what were previously craft activities, and the belief in the authority of the intellect, are applicable just as much to the practice of, for example, music, drama and dance as they are to fine art.

Before the English Civil War, various attempts had been made to establish organisations that were loosely described as academies and existed to encourage the free exchange of ideas between the liberal arts. In 1617 Edmund Bolton, a Catholic antiquarian, proposed the establishment of an 'academ roial' to the Earl of Buckingham, but this was to be devoted primarily to the study of history and antiquities. Henry Peacham, a schoolmaster who developed an interest in the arts, published *The Complete Gentleman* in 1622, in whose pages he advocated the idea of an academy in which gentlemen could learn about drawing, painting and the history of art. In 1649 Balthazar Gerbier, a fascinating and rather cranky Huguenot,

opened what he described as an academy in Bethnal Green with a curriculum that ranged from foreign languages to the construction of military fortifications.

Following the Restoration, Sir Peter Lely, the most important portrait painter in the reign of Charles II, established what he described as an academy. Attached to his studio in the northeast corner of the Covent Garden Piazza, this was a place for students, including his own pupils, to learn to draw. An album preserved at Dulwich College includes drawings presumed to have been made at this academy, including examples by George Freeman, whom Lely greatly encouraged, and by Lely's pupil John Greenhill, of whose skill he is said to have been envious.

By the end of the seventeenth century, the idea of establishing a formal academy for the training of artists was well established in government circles. Narcissus Luttrell, who wrote a diary while he was a Member of Parliament, recorded in 1698: 'His Majestie [William III] is resolved to settle an academy to encourage the art of painting, where are to be 12 masters, and all persons that please may come and practice gratis.' Nothing came of this proposal, but there was already an informal group called the Virtuosi of St Luke, whose meetings are said to date back to the time of Van Dyck and who met in a tavern to eat Westphalian ham, talk about the collecting of art, and campaign for the establishment of an academy.

In looking at the history of academies, it is clear that there were rival pressures: one has been top-down, most obviously exemplified by the Académie Royale de Peinture et de Sculpture in Paris, which was quite openly an initiative of the monarch, established by the French state in order to boost the luxury trades and improve foreign exports, as well as the character and quality of French state art; the other has been bottom-up, whereby groups of artists met to discuss the nature of their art practice and tried to give it a formality through the establishment of a group, with monthly meetings, a President and secretary, and the formalities of a collective association.

In Britain, the movement towards an academy has tended to be bottom-up. During the first half of the eighteenth century, there were constant initiatives to create artists' societies of one sort or another, and these normally involved drinking, dining and discussion, alongside opportunities to improve the practice of art through classes for life drawing.

The best known of these groups was the so-called 'Accademy of Painting', which came into being on St Luke's Day 1711 when a group of leading artists met on the ground floor of a grand house in Great Queen Street in Covent Garden to establish an academy of painting and drawing. Sir Godfrey Kneller, by far the richest and most successful portrait painter of his day, was elected its Governor. Over sixty people attended, including the antiquary George Vertue, who described the occasion in his Notebooks. At the heart of the establishment of this early academy, as of subsequent ones, was the provision of an opportunity for life drawing. By paying a guinea, artists were able to improve their skills in drawing. Behind all the academies of the eighteenth century lay the aspiration to escape from the drudgery of scene painting and portraiture in order to create a proper, public art.

But this first academy did not last. The establishment of an academy in England was to remain an uphill struggle for a long time. Indeed, artists in the eighteenth century seem to have had an almost infinite capacity to fall out with one another, to quarrel about the best form of practice, and quickly to create splinter groups within any newly established organisation. This was what happened to the first academy. Kneller resigned in 1716 to be replaced by James Thornhill, who was unusual among artists of the time in having been born in England and a member of the gentry.

In 1719 Jonathan Richardson, a portrait painter, published *Two discourses: I. An essay on the whole art of criticism as it relates to painting, and II. An argument in behalf of the science of a connoisseur*, which included a plea for the establishment of a formal academy on continental lines:

... if our Nobility and Gentry were Lovers and *Connoisseurs*, Public Encouragement, and Assistance would be given to the Art: Academies would be set up, Well Regulated, and the Government of them put into Such Hands, as would not want Authority to maintain those Laws, without which no Society can Prosper, or long Subsist. These Academies would then be well provided of all Necessaries for Instruction in Geometry, Perspective, and Anatomy, as well as Designing, for without a competent Proficiency in the three former, no considerable Progress can be made in the Other. They would then be furnished with Good Masters to Direct the Students, and Good Drawings, and Figures, whether Casts or Originals, Antique, or Modern for their Imitation. Nor should these be consider'd merely as Schools, or Nurseries for Painting, and Sculptors, and other Artists of That kind, but as places for the better Education of Gentlemen, and to Complete the Civilizing, and Polishing of our People, as our Other Schools and Universities, and the Other means of Instruction are.

Richardson's idea was that an academy would train not just artists, but lovers of art as well; but, in practice, the artists preferred the idea of a discrete organisation that would concentrate on more specifically professional skills, particularly drawing.

In 1720 a rival academy was set up in St Martin's Lane by Louis Chéron, an elderly Huguenot, and John Vanderbank, who had inherited money from his father, the owner of the Soho Tapestry Manufactory in Great Queen Street. This academy was really just a drawing school at the heart of the district where artists and tradesmen had their studios and workshops. Thirty-five subscribers each paid two guineas annually to have access to regular sessions of drawing from the living model, as well as instruction in elements of anatomy from William Cheselden, a surgeon who had published *The Anatomy of the Humane Body* in 1713. In 1722 this academy was advertised as an 'Academy for the Improvement of Painters and Sculptors by drawing from the naked', but it closed down in November 1724 when its equipment was confiscated by their land-

lord and Vanderbank left for Paris. In its place, Thornhill opened a free academy at the back of his house in Covent Garden, where his son-in-law, William Hogarth, learned to draw.

The next key moment was in the winter of 1735, when Hogarth (plate 6) took over his father-in-law's 'neglected apparatus' and established a new academy in St Martin's Lane, with a subscription of two guineas for the first year, but reduced to a guinea and a half

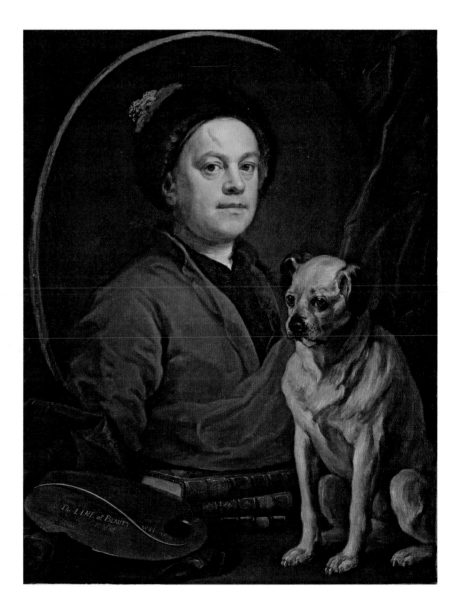

6. William Hogarth,
The Painter and His Pug, 1745

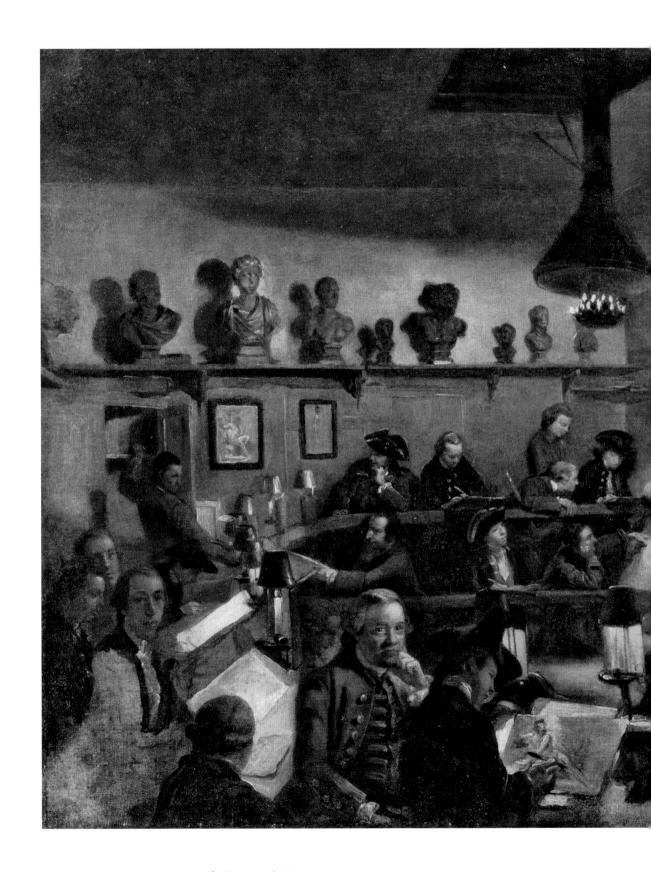

7. Johan Zoffany, *A Life Class (possibly at the St Martin's Lane Academy)*, *c.* 1761

each year thereafter. Writing at the end of his life, Hogarth attributed 'the failure of previous academies to the leading members having assumed a superiority which their fellow-students could not brook'. He had proposed

> that every member should contribute an equal sum towards the support of the establishment, and having an equal right to vote on every question relative to its affairs. By these regulations the academy has now existed nearly thirty years, and is for every useful purpose equal to that in France or any other.

The St Martin's Lane Academy was, as Hogarth recognised, quite successful and certainly serviced the need for artists to have access to drawing classes (plate 7). But it stopped short of being an academy in the European sense because it did not treat the practice of art as an intellectual pursuit and was possibly, as Hogarth was its leading figure, deliberately anti-intellectual and hostile to anything that smacked of European academic practice. However, it did not prevent writers and commentators continuing to lament the lack of a more fully fledged system of academic training for artists in Great Britain and aspirations on the part of many to establish a more formal organisation.

The limitations of Hogarth's academy were described in 1747 in Richard Campbell's *The London Tradesman*, in which Campbell deplores the absence of proper facilities for the training of artists:

> The present State of this Art [i.e. painting] in *Britain* does not afford a sufficient Education to a Painter. We have but one Academy meanly supported by the private Subscription of the Students, in all this great Metropolis: There they have but two Figures, one Man and a Woman; and consequently there can be but little Experience gathered, where there are neither Professors nor Figures.

Two years later, George Vertue drew up detailed plans for the training of artists that involved the establishment of three drawing schools – in London, Oxford and Cambridge – under masters who

were to be appointed by an academy. The students were to be made to copy from specially produced books and casts from the antique and to study anatomy, geometry, architecture and perspective. Frederick, Prince of Wales, was interested in the project and, in November 1749, there was a meeting at the Bedford Head Tavern in Southampton Street (map key 5), 'to settle the preliminarys for the Establishment of an Accademy – in London'.

What one sees in all these early projects and proposals is a conflict between the ideas of the artists, who in general tended to want something that approximated to the facilities of a trade school (i.e. access to a model for the purpose of improving their abilities in drawing); and a more liberal idea of an art school that was expected to be more disciplined and more intellectual in its approach. Nothing came of Vertue's project to establish an academy in 1749, probably because it was expected to be established under the auspices of the Society of Dilettanti, a smart drinking club dominated by members of the nobility with an interest in travel and classical antiquity. The great majority of artists, and particularly Hogarth, wanted any such establishment to be self-governing, run by artists and not in any way subject to the external authority of patrons and connoisseurs.

During the 1750s there were several further attempts to establish an academy. In 1753 the Society of Dilettanti took the initiative and decided to construct a grand building on Cavendish Square, based on the Temple of Pola in Croatia, to house both a museum and an academy (plate 8). The artists associated with the St Martin's Lane Academy, apart from Hogarth, wanted to be involved and so Francis Milner Newton, a painter who had a talent for administration and was heavily involved in this and all subsequent such initiatives, issued the following circular:

> There is a scheme on foot for creating a public academy for
> the improvement of painting, sculpture and architecture; and it
> is thought necessary to have a certain number of professors,
> with proper authority, in order to making regulations, taking

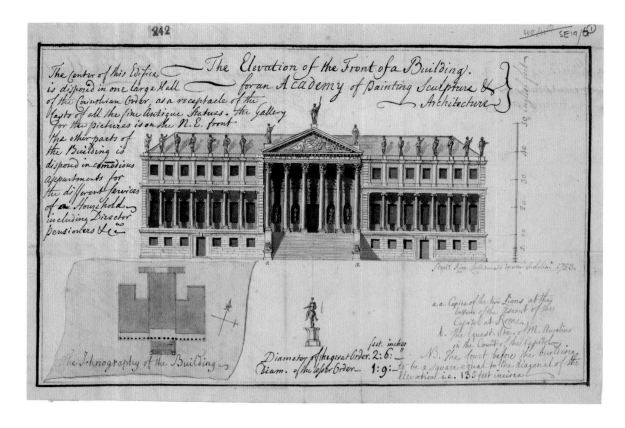

8. Stephen Riou, *Design for the Society of Dilettanti's Academy of Painting, Architecture and Sculpture*, 1753

subscriptions, &c., erecting a building, instructing the students, and concerting all such measures as shall be afterwards thought necessary.

Your company is desired at the Turk's Head, in Gerard Street, Soho, on the 13th. of November, at five in the evening, to proceed to the election of thirteen painters, three sculptors, one chaser, two engravers, and two architects, in all twenty-one, for the purposes aforesaid.

Just over a year later, on 31 January 1755, this same group of artists published a sixteen-page pamphlet entitled *The Plan of an Academy for the better Cultivation, Improvement, and Encouragement of Painting, Sculpture, Architecture, and the Arts of Design in General.* They wanted an academic programme for the teaching of art, to include copying after the antique, life classes, professorships and lectures, as well as provision for 'a yearly Exposition of Pictures Statues or Models & Designs in Architecture of the Fellows of this Academy'. They sent their proposal to the Society of Dilettanti in a slightly different form, with changes in the manuscript that are likely to have been made by Francis Milner Newton. The text is rather a magnificent piece of rhetoric, including such high-flown sentiments as 'That the Wooden Prints and Bellmen's Verses, which are the Pride of Garrets and Cellars, have their Rise from the said Origine which has introduced the Works of Correggio, Titian, Raphael, Rubens &c &c unto the Magnificent apartments of the Great.'

In March 1755 the *Gentleman's Magazine* published a very full description as to how an academy might operate. This it attributed to the seventeenth-century antiquarian and diarist John Evelyn, whose *Sculptura* had just been published in a new edition:

It is proposed that a house be taken, with a sufficient number of rooms: two, contiguous to each other for drawing and modelling from the life; one for architecture and perspective; one for drawing from plaister; one for receiving the works of the school; one for the exhibition of them; and others for a housekeeper, and servants.

That some fine pictures, casts, bustoes, bas relieves, intaglia's, antiquity, history, architecture, drawings, and prints, be purchased.

That there be professors of anatomy, geometry, perspective, architecture, and such other sciences as are necessary to a painter, sculptor or architect.

That the professors do read lectures at stated times on the constituent parts of their several arts; the reasons on which they are founded, and the precision and immutability of the objects of true taste, with proper cautions against all caprice and affectation.

That living models be provided of different characters, to stand five nights in the week.

That every professor do present the academy with a piece of his performance at admission.

That no scholar draw from the life, till he has gone through the previous classes, and given proof of his capacity.

That a certain number of medals be annually given to such students as shall distinguish themselves most.

That every student, after he has practiced a certain time, and given some proofs of his ability, may be a candidate for a fellowship.

That such of the Fellows as chuse to travel to *Rome* to complete their studies, do make a composition from some given subject, as a proof of their abilities; and he who shall obtain the preference, shall be sent with a salary, sufficient to maintain him decently a certain time, during which he is to be employ'd in copying pictures, antique statues, or bas-relievos, drawing from antient fragments or such new structures as may advance his art, such pieces to be the property of the society.

That other medals of greater value, or some badges of distinction be given publickly to those who shall manifest uncommon excellence.

That some professors should be well skilled in ornaments,
fruit, flowers, birds, beasts, &c. that they may instruct the
students in these subjects, which are of great use in our
manufactories.

That drawing-masters for such schools as may be wanted
in several parts of the kingdom be appointed by the professors
under the seal of the academy.

That a housekeeper shall continually reside at the Academy,
to keep everything in order, and not suffer any piece to go
out of the house without a proper warrant.

Slightly bizarrely, this description is almost certainly fictitious.
It does not appear in any edition of *Sculptura*, nor apparently in any
other book by Evelyn. In fact, its cadences and style of writing
belong more to the eighteenth than the seventeenth century. The text
appears to be a very loose adaptation of a proposal that Evelyn made
for the establishment of a mathematical school in a letter to the
scientist Robert Boyle on 3 September 1659. Someone (perhaps
Thomas Sandby, since it was published as Evelyn's work by Sandby's
great-nephew William in his *History of the Royal Academy of Arts from
its foundation in 1768 to the present* of 1862) was trying to dress up the
idea of an academy and work out how it might operate in quite
elaborate detail, pretending that this was a longstanding project
dating back to the Restoration in order to give it legitimacy.

Nothing happened. According to Hogarth's friend Jean Rou-
quet, this latest project for an academy 'did not take place, either
because it was ill planned, or because its inutility must have naturally
produced its ruin'.

While the Society of Dilettanti and a group of artists were
making their plans, a young entrepreneur called William Shipley,
who had been teaching drawing in Northampton, held a meeting at
Rathmell's Coffee House on the north side of Henrietta Street in
Covent Garden (map key 4) to establish the rather grandly named

'Society for the Encouragement of Arts, Manufactures, and Commerce', a title generally shortened to the 'Society of Arts'. Although its purposes were much broader, the Society of Arts did a great deal to encourage the teaching of drawing by the award of quite substantial prizes (or premiums) for young artists, including special prizes for children of the nobility. Among the first prizewinners in 1755 was Richard Cosway 'for a Drawing in Chalk'. Many of the early Academicians first came to public notice by winning awards in the annual prizegiving of the Society of Arts, including John Bacon, who won a prize for a figure of Peace in 1759; Thomas Banks, who was awarded premiums in 1763, 1765 and 1766; and Mason Chamberlin, who was awarded fifty guineas, a huge amount, for 'an Historical Oil Painting' in 1764.

The Society of Arts was a key institution in furthering public interest in the arts. And William Shipley also established a small drawing school, originally in Craig's Court and afterwards in a house near the Strand at the corner of Beaufort's Buildings (map key 7), in which he taught a number of those who were later to enrol in the Royal Academy Schools.

In 1758 another school to teach drawing was established, this one alongside the Duke of Richmond's sculpture gallery in the Privy Garden, Whitehall (map key 14), where the Duke had assembled a collection of casts after the antique made by Joseph Wilton and Matthew Brettingham and where he allowed admission to 'any painter, carver, sculptor or other artist and youth over twelve years of age, to whom the study of statuary might be useful'. Pupils there, who included John Hamilton Mortimer and Joseph Wright of Derby, were apparently taught to draw by Joseph Wilton and Giovanni Battista Cipriani and, like those attending Shipley's drawing school, were eligible for special prizes from the Society of Arts.

The next key moment in the prehistory of the Royal Academy

was the decision on the part of a large group of artists to establish a society that would oversee an annual exhibition. On 5 November 1759, a dinner for artists was held at the Foundling Hospital. John Wilkes, a young rake with political ambitions, who spent part of his time in Buckinghamshire and part in London, was in the chair. Francis Hayman (plate 9), a successful, mid-career painter who had made a good living undertaking portrait commissions but had also branched out into other media, including book illustration, was known to want to establish an institution that would be run by artists and promote contemporary art, unlike the British Museum, which had been founded in 1753 for the study and preservation of works of antiquity. After dinner, the artists sang an ode in honour of Francis Hayman's desire to found 'A great Museum all our own'.

By the end of the evening, the artists were all fired up and had drawn up a resolution in which they announced:

> That a general meeting of all Artists in the several branches
> of Painting, Sculpture, Architecture, Engraving, Chasing,
> Seal-cutting, and Medalling, be held at the Turk's Head Tavern,
> in Gerrard Street, Soho, on Monday, the 12th inst., at Six in
> the evening to consider of a proposal for the honour and
> advancement of the Arts, and that it be advertised in the
> *Public* and *Daily Advertisers*.

The following week, a group of artists met once again at the Turk's Head Tavern in Gerrard Street (map key 1), evidently the standard place of rendezvous for artists, many of whom had studios in the neighbourhood. They resolved to establish an annual public exhibition, which would be held, at least to begin with, in the Great Room of the Society of Arts, a building designed by William Chambers in Little Denmark Court, just off the Strand (map key 6). The first such show opened on 21 April 1760 and was wildly successful. Over a thousand visitors a day attended, not far short of the number of visitors to the Summer Exhibition today. This

9. Sir Joshua Reynolds, *Portrait of Francis Hayman*, 1756

demonstrates the astonishing public appetite for an opportunity to see paintings outside the realm of churches and private houses.

The following year the exhibition moved to Christopher Cock's Auction Rooms in Spring Gardens (map key 10), a street just west of Charing Cross, and the artists established themselves as 'The Society of Artists of Great Britain'. Some 13,000 people bought a copy of the exhibition catalogue, with its engraved frontispiece designed by William Hogarth showing George III surveying a scene in which Britannia waters three trees, representing the arts of painting, architecture and sculpture (plate 10).

The establishment of the Society of Artists in 1761 to oversee an annual exhibition might have led, by a natural process of evolution, to a more formal academy that also encompassed the training of artists. In January 1765 the Society of Artists was incorporated by royal charter, which indicates that its members wanted to be constituted in a rather different – and much more formal – way from previous artists' societies, which had suffered from being too casual. The terms of the royal charter were uncannily similar to those for the Royal Academy not long after: 'We give and grant to the said Society that they shall and may, hold meetings of themselves, for the better improvement, and encouragement of the Arts of Painting, Sculpture and Architecture, Drawing, and other Arts depending thereupon.' The obligations required of new members were also remarkably similar to those that were later to be required of Academicians of the Royal Academy:

> We whose Names are hereunto Subscribed do hereby promise
> each for himself that we will to the utmost of our Power, promote
> the Honour and Interest of the Society of Artists of Great-Britain,
> and that we will Observe and conform to all such Statutes and
> Orders which are or shall be made (pursuant to the meaning and
> Intention of the Charter) for the Government and Regulation
> of this Society, so long as we continue Members thereof.

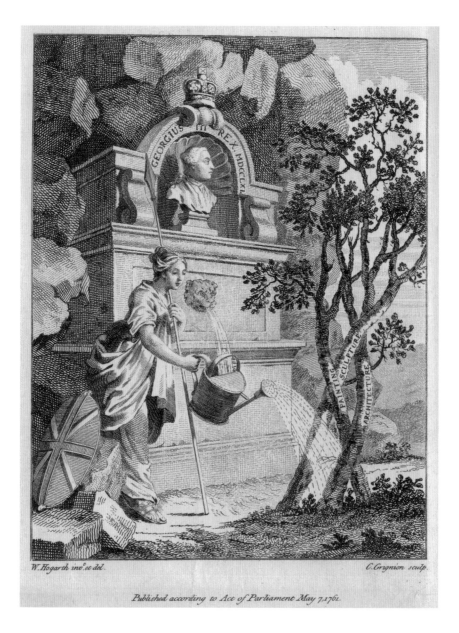

10. Charles Grignion after William Hogarth, *Britannia Nurturing the Fine Arts from the Fountain of Royal Munificence*, from the frontispiece to the catalogue of the exhibition of the Society of Artists, 1761

Following incorporation, members of the Society of Artists were known as Fellows and members of its governing body were Directors. The use of these terms is further evidence of the members' aspiration to create a more formal, ritualised organisation, modelled on the Royal Society, which had a procedure of election to a Fellowship. George Lambert, a landscape painter who had been involved in the previous plan to establish a national academy of arts under the auspices of the Society of Dilettanti in 1755, was elected President, but died four days later. Francis Hayman, then involved in an ambitious project to paint four history paintings for the Rotunda at Vauxhall Gardens, succeeded him, having been Vice-President. Richard Dalton, the King's librarian and a key figure in previous efforts to establish an academy, was Treasurer. Francis Milner Newton, who had also been very closely involved in earlier attempts to bring an academy into being, became Secretary. Twenty Directors were appointed, including William Chambers, Joseph Wilton and George Michael Moser, but not Joshua Reynolds, perhaps because he preferred the company of writers to that of artists.

So, what went wrong?

2 *Quarrelling*

It all began with a monumental row.

In March 1767 the Society of Artists decided that it might turn itself into an academy, so that, if possible, it could support not only an annual exhibition, but also facilities for teaching. Its members passed a resolution at one of their quarterly meetings that the Directors 'should consider of a proper form for instituting a public academy, and to lay the same before the quarterly meeting'.

But the Directors had ideas of their own. Without consulting the Fellows and with help from Richard Dalton (plate 11), their Treasurer, they planned to reshape the Society as an academy under the auspices of the King. They set up arrangements for teaching in Lambe's Auction Rooms, whose lease Dalton had inherited from his father. The rooms were at the east end of Pall Mall, next door to Carlton House (map key 12), with a large, top-lit room, hung with green baize. They had previously been used by Dalton in an unsuccessful business venture as a warehouse for the sale of Old Master prints, which he had shipped over from Italy. George Michael Moser managed to get hold of much of the necessary equipment for teaching, including 'anatomical figures, bustoes, statues, lamps and other effects', from the St Martin's Lane Academy with a promise that the newly established academy would have the advantage of royal patronage and not require an annual subscription. A sign announcing 'The Royal Academy' was put up over the front door.

Two months later, the Free Society of Artists, which was a rival to the Society of Artists and, as its name suggests, did not charge entry to its exhibitions, was told that Lambe's Auction Rooms would not be available for its annual exhibition because they were 'required for the art school founded about this time, and taken over by the Royal

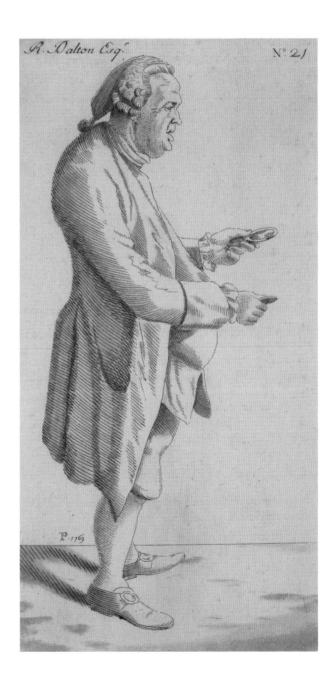

11. Thomas Patch, *Caricature of Richard Dalton*, 1769

Academy'. In other words, the establishment of a royal academy was first planned by the Directors of the Society of Artists, believing that the support of the King would give them the status that they sought.

The transformation of the Society of Artists into the Royal Academy might have run smoothly, but for the fact that, as in all groups and societies (and, it seems, particularly in those consisting of artists, who are inclined to be hot-tempered and fractious, not just in the eighteenth century), there were all sorts of simmering discontents, small jealousies and petty feuds. The younger artists resented the authority of their elders and felt that the older artists gave themselves preferential treatment in the way that the pictures were hung in the annual exhibition. They did not want their Society to come under the auspices of the King. They were annoyed that they had to share their drawing classes with the activities of auctioneers and dancing masters, whom Dalton also allowed to rent the space. And they had the strongest possible suspicion that Dalton had only suggested using Lambe's Auction Rooms because he had previously been using them to run his own commercial print-dealing business, which was about to go bankrupt. Above all, in exactly the same way as has happened throughout the Royal Academy's history, a deep conflict emerged over where the authority lay to make and approve new Laws. Did power reside with the Directors or the broader membership?

In 1766 the rank-and-file of the Society of Artists started meeting every week at Munday's Coffee House in Maiden Lane (map key 8) in a little sub-group of younger members. This they called the Howdalian Society (plate 12) after Captain Howdell, a friend of theirs who was also a 'great friend and lover of art' and had recently been posted as an army officer to Minorca. This sub-group included Thomas Jones, a young Welsh artist who was quite well-to-do and had been educated for the Church at Jesus College, Oxford (plate 13); John Hamilton Mortimer, a fiery and rebellious figure who had

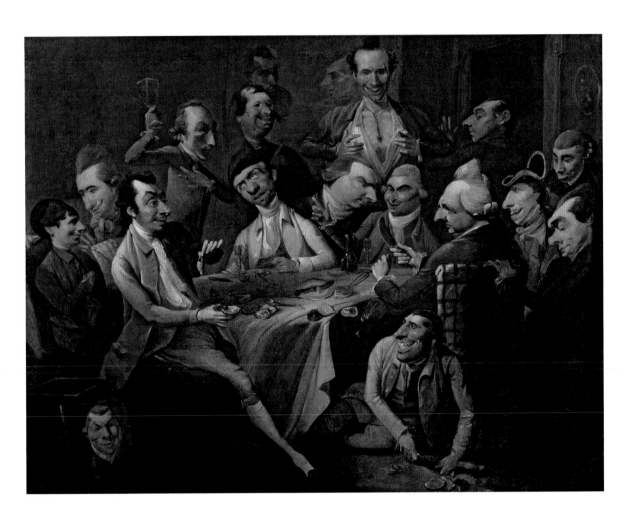

12. John Hamilton Mortimer, *A Caricature Group Including Members of the Howdalian Society*, *c*. 1766

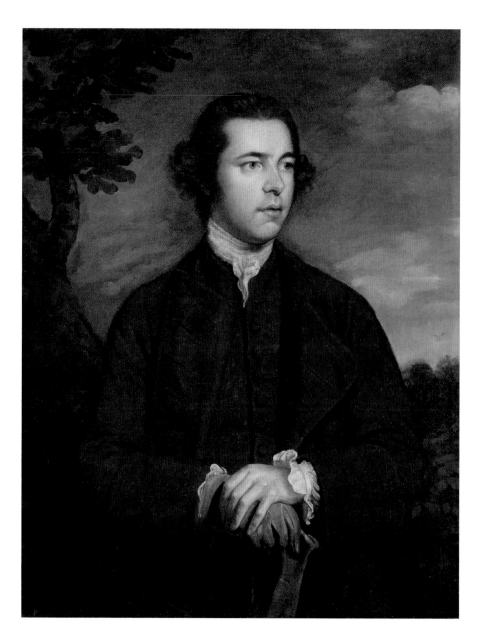

13. Giuseppe Marchi, *Thomas Jones*, 1768

studied under Robert Edge Pine (known to hold republican views) and was mad about history painting; the architect James Gandon, a pupil of William Chambers; and the painter Joseph Wright of Derby, who was outside the metropolitan clique and slightly older. Wright of Derby apparently had a good singing voice and much of the Howdalian Society's time was spent singing glees. But they also discussed what could be done to make the Society of Artists more representative of the interests of its younger members. They particularly objected to the fact that there was so little turnover among the Directors who ran the Society, and so they decided to introduce a new bye-law that would compel either eight or twelve of the twenty-four Directors (they eventually settled on eight) to stand down each year and to offer themselves for re-election.

In March 1768 Richard Dalton resigned in a huff from the post of Treasurer, presumably irritated by the constant insinuations that he had encouraged the Society to take over the use of Lambe's Auction Rooms only because he had got himself into financial difficulties by using them for his print business. He wrote an irate letter of resignation saying that he was disgusted by the behaviour of those he described as 'malicious dark spirits' who, he thought, were 'ever ready to alarm or rouse the furious or wrong-headed to disturb the peace of the Society'.

Tuesday 7 June 1768 A General Meeting of the Fellows took place. James Paine (plate 14), a well-established but now slightly old-fashioned architect who had made his reputation in the north of England by publishing a grand folio volume of plans for his Mansion House in Doncaster, had been encouraged to think that he would be the architect for the Society's new exhibition rooms in the Strand. He discovered to his fury that they were now to be designed by William Chambers, a rival, smarter and more internationally minded architect who had taken over from Dalton as Treasurer of the Society. Paine resigned in high dudgeon

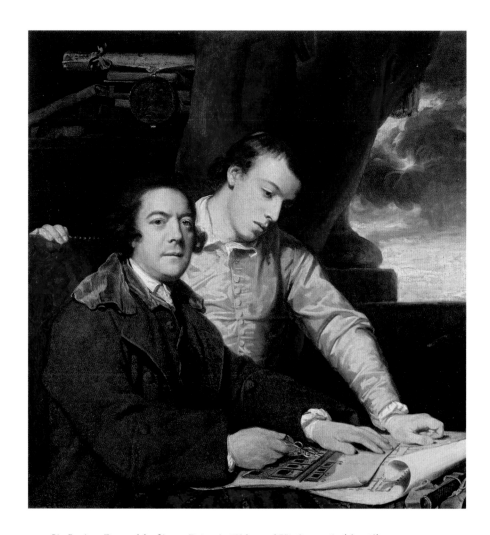

14. Sir Joshua Reynolds, *James Paine the Elder and His Son*, 1764 (detail)

and became the ringleader of the opposition. According to Thomas Jones, recollecting what had happened when he came to write his *Memoirs* in old age, the dispute that followed 'originated in the private feud of two rival Individuals, and in that alone'. It is certainly plausible that the origins of the Royal Academy lie in the differences of opinion between two architects, both prickly and both, in different ways, high-minded. But it was more complicated than that and involved issues of principle as to whether the authority to run the Society effectively lay with the Directors.

Later in the same meeting, the rebels insisted that the Directors seek the advice of William de Grey, the Attorney General, on the legality of their plan to introduce a new Law to limit the length of time that Directors could hold office.

Thursday
9 June 1768

At their meeting the Directors decided to ask a lawyer, Thomas Theodosius Forrest, who had previously exhibited paintings at the Society of Artists (and whose father, Ebenezer Forrest, had been a friend of Hogarth), to attend a meeting in order to help them frame the question that they were planning to put to the Attorney General. They wanted to know whether or not they had a legal obligation to consider the proposed new bye-law and whether or not a limit on the duration of Directorships would be contrary to the welfare of the Society. The question they decided to put to the Attorney General was: 'Whether any by-law to deprive a *director* of the privilege of being re-elected, at any annual election, will, or will not be inconsistent with, and repugnant to the directors of the charter.'

Saturday
13 August 1768

The Attorney General's opinion was not at all what the Directors had wanted. He acknowledged that they were 'under no *legal* Obligation of taking into Consideration a Resolution of a General Meeting in order to form it into a Bye Law', but pointed out that, at the same time, the terms of the Charter under which they operated recognised

that 'the Directors are to make Laws but the Body has a Power of rejecting or approving'. The point at issue was whether or not the Directors were in charge of the Laws or whether a General Meeting of the Fellows as a whole had the authority to introduce a new Law without recourse to the Directors. Overall, de Grey found himself unexpectedly in sympathy with the views of the rebels, feeling that the new law that they had proposed was a legitimate way of curbing the power of the Directors:

> I am of Opinion that such a Bye Law as is Proposed is not Inconsistent with the Charter, but a regulation of the Mode of Elections, to prevent the whole Power of the Society being engrossed by a Part, & to leave a Share of the Direction, in some small Degree, more Open to the Community.

This was quite a radical statement for an eighteenth-century Attorney General. The language concerning both the opening up of elections to a broader community and the curbing of the authority of the government in power is derived to a surprising extent from some of the debates in the pamphlet warfare that had taken place in 1763 surrounding the prosecution of John Wilkes for libel, his trial in 1764, and his return to England from exile in 1768 to stand in the Middlesex election. It is particularly surprising in that de Grey led the government's case against Wilkes the following year.

Tuesday
6 September 1768

The Attorney General's opinion was read out to the Fellows at a General Meeting and, not surprisingly, they immediately insisted that their new bye-law be introduced forthwith. They took a vote and twenty-two were in favour, with only twelve against. The Directors were given two weeks to finalise the wording of the new bye-law before another General Meeting was to be held to confirm it.

Friday
9 September 1768

Rather than acknowledge the verdict of the Attorney General, as surely would have been sensible, the Directors decided against conciliation. They issued a robust statement, explaining how much they

resented the proposal and regarded it as an ill return for all their hard work in managing the affairs of the Society:

> That as the making a Law to exclude Directors from being chosen the succeeding year would be an attack upon the freedom of Elections, a dangerous Innovation of our Charter, and an ungrateful return to Directors for their trouble and care in the management of the business of the Society, we are clearly of opinion no such Law should Pass [and] therefore we have rejected the proposal[.] We hope that the Impartial Part of the Society will think we have acted right with regard to the many attempts which have been made in the Society to bring such a Law to bear, we look upon them as the Efforts of a few designing Persons and as they have always been prefer'd with Clamour & indecent behaviour, it cannot be expected that we should pay any attention to them.

This was wilfully inflammatory. According to Thomas Jones, 'all the good humour of our jolly President, *Fran. Hayman*, was not able to persuade the disputants to lay aside their mutual Bickerings, and drown their Heartburnings in bumpers of wine'.

*Wednesday
5 October 1768*

A meeting was held at the Piazza Coffee House in Covent Garden (map key 2), a rather louche area at the time, which tended to be used as a place of night-time assignation for prostitutes. A sub-group of the Fellows discussed what should be done. Jones gives a very clear description of the troubles in his *Memoirs*:

> The 24 Directors being composed of the most established Artists, and men of the greatest Influence; had made use of that Influence so much over the junior part of the Society, many of whom had been their Pupils, that they always maintained a Majority in their own favour at all ballotings – By these means they constantly kept them selves in the Directory, monopolizing those powers and priviledges which the rest ought to have had a chance in sharing – Now the partial behaviour of the Directors, in rejecting some, and illplacing other Meritorious performances at the Exhibition, that they themselves might engross the best and most honourable

places, concurring with some personal Insults received from them, induced Such of the Fellows as thought themselves aggrieved, to form a party in Opposition, and see whether their Interest might be powerful enough to introduce into the Society a Bye Law, by which 12 of the Directors were obliged to be changed annually.

Jones was not the only person to refer to the fact that the hanging policies of the Directors were one of the major causes of contention. Francis Cotes, in particular, was described in a formal complaint to the Directors as 'occupying all the best places in the Exhibition'. He had upset everyone by insisting that the two pictures that he had shown in the 1767 exhibition, one of the Queen and the other of the Duchess of Hamilton, were hung extremely prominently, thereby giving 'never pardoned offence among his brethren'.

Thursday
13 October 1768

The rebels, led by James Paine, issued the following, fairly aggressive statement, objecting to the actions of the Directors:

> SIR, At the last General Quarterly Meeting of the SOCIETY of ARTISTS, a Law was proposed (and carried by a great majority) to secure the Election of *Eight* new DIRECTORS Annually: This Proposition for a Law being referred to the Directors, has since been returned with their Absolute Refusal, notwithstanding the Attorney General's Opinion that the Society *has full Power* by their Charter, *to make such LAW*; and to which Opinion they the Directors had previously determin'd to abide; and as a further Aggravation, it must be observ'd, that the Directors were not satisfied with this use of their Power; but added to it most reproachful Reflections on the Fellows of the Society. This is therefore to desire your Attendance on *Thursday* next at Six o'Clock, at the *Castle-Tavern, Henrietta Street, Covent-Garden*, to meet the rest of the Fellows of the Society, in order to consider on the Proper Persons to serve as Directors for the Year ensuing, whereby it is hoped that such Persons will be named who will consider the general Interest of the Society.

Tuesday
18 October 1768

There was an election. Hayman, who had succeeded Lambert as President, was defeated and Joshua Kirby (plate 15), an artist who had spent much of his career in Ipswich before being taken up by the Earl of Bute and made Clerk of Works at Kew, was elected President in his place.

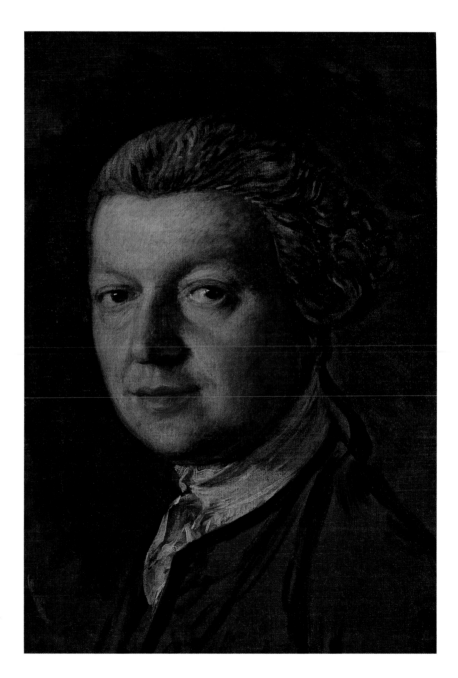

15. Thomas Gainsborough,
Portrait of Joshua Kirby,
c. 1754–6

What exactly was the cause of the extreme fractiousness of this dispute? Superficially, it was only about the introduction of a new Law. But laws are the social tissue that binds societies together and they can, on occasion, blow them apart. They describe the hierarchy of authority and define how decisions are made. The Directors of the Society of Artists were determined to resist the rebels' attempts to undermine their authority. They had been trying for the last five years to enhance the prestige of the Society of Artists and thereby the status of artists more generally, and they felt that their efforts deserved recognition. Those who were not Directors resented the Directors' monopoly on authority. Close to the surface in the dispute was the ghost of Hogarth (he had died four years before), who had always resisted too obvious a hierarchy in the St Martin's Lane Academy and disliked anything that he thought smacked of the French model of top-down authority. It happened that Joshua Kirby was an old friend and associate of Hogarth. A blustering, rather jovial man, he did not have the same intellectual pretensions as the Directors and represented the older tradition of democratic collegiality.

Friday
4 November 1768

The new Directors of the Society of Artists met and decided to proceed with the introduction of the new Law. William Chambers was apparently absolutely apoplectic and 'broke forth into much coarseness, and indecency of expression'. According to the Scottish engraver Robert Strange, who wrote an extremely rude account of the foundation of the Royal Academy, motivated by a long-standing sense of grievance stretching back to the fact that Richard Dalton had hired Francesco Bartolozzi rather than him to make engravings of Old Master paintings in Bologna:

> M. Chambers, forgetting that decency of behaviour which is
> expected from men in all civilised societies, gave way to passion
> and resentment, and threw out many unbecoming reflections
> against the newly elected directors; insomuch, that several of
> his own party were ashamed of his conduct. He left the room

in a precipitate manner, but, sensible of the impropriety
of his behaviour, he afterwards wrote letters to several
of the directors apologizing for it.

Following this meeting, eight of the Directors of the Society of
Artists resigned. They were: William Chambers, unsurprisingly;
George Michael Moser; Francis Milner Newton, the Secretary;
Edward Penny, a history painter who had been Vice-President to
Francis Hayman; Paul Sandby, a topographical artist who had been
trained as a draughtsman working for the Board of Ordnance in
Scotland; Benjamin West, a young American, regarded by many as a
rising star; Richard Wilson, the Welsh landscape painter, who was at
this stage in his career turning to drink; and the sculptor Joseph
Wilton.

All were to be deeply involved in the establishment of the Royal
Academy. They obviously came up with the idea, which had already
been mooted when they were Directors of the Society of Artists, of
seeking the support of the King for a formally established royal
academy. They wanted it to be more selective in its membership than
the Society of Artists, more of an élite group within the practice of
art, whose members would seek to reinforce the continental model of
art and architectural practice, to support the genre of history paint-
ing, and to foster the belief that art was an intellectual pursuit that
required an appropriate system of training. It is hard to escape
the impression that there may have been an element of intellectual
snobbery about their attitude towards the Society of Artists, which
they may have regarded as too democratic, too broad-based in its
membership (at the time it had 211 members), as well as being much
too fractious a body to permit effective management.

As always happens in these sorts of disputes, the disagreement
was partly a matter of principles and partly one of personalities.
Chambers did not like James Paine. They differed in their attitudes
concerning the appropriate system of training for architects, Paine,
like Hogarth, disparaging the need for young architects to study

abroad and almost certainly envious of the fact that Chambers enjoyed so much support and patronage from the King, including being employed on the remodelling of Buckingham House. Those Directors who resigned from the Society of Artists on 4 November 1768 all seem to have been united in their desire to establish a more select society of artists who had mostly been trained abroad, which would keep out the riff-raff, i.e. the younger, more democratically inclined artists. They wanted to be able to run the new operation in such a way that they would not be subject to endless criticism. They wished to be, as Reynolds described it in one of his Discourses, 'respectable'.

They wrote a collective letter of resignation to Joshua Kirby:

> You will perceive by the tenor of the inclosed to you as President of the Society of Artists of Great Britain, that we have resigned our Directorships. We are very sorry to quit a President for whom we have the highest regard; as likewise several of the Directors, who tho: elected by the Cabal; had no share in their intrigues, but the ungenerous treatment which we and the rest of our friends have met with from the Caballers and their obstinacy in still continuing to insult us, by proposals which they know to be diametrically opposite to our sentiments (because we think them repugnant to the true interest of the Society), render it impossible for us to continue in Office with any degree of decency. We hoped that the harmony, which you and every friend of the Society wished for; would have been brought about; but finding the same turbulent Spirits who first raised the divisions amongst us, still bent upon widening the breach, we think the shortest method is to decline all commerce with them. We most heartily wish you health and success in all your undertakings and beg you will believe us to be Dear Sir Your sincere friends and most obedient humble servts.

Tuesday
22 November 1768

Joshua Kirby wrote to his brother:

> You have heard, I apprehend, that I have been made President of the Society of Artists of Great Britain. It is an honour unexpected and undeserved. It is very like dressing a man in

a fine robe, and then fixing a weight to the train of it that he with all his abilities is but just able to tug after him. I am placed at the head of a respectable but divided body of men. God grant that I may be able to introduce that kind of union amongst them that I sincerely wish could be effected through every part of this divided and distracted Kingdom.

Friday
25 November 1768

In his absence, Joshua Reynolds had been elected a Director of the Society of Artists. If he had not already been told of the plans to create a rival organisation, he must have sensed that there was trouble afoot. So, he sent a dignified letter of refusal to Kirby:

> I beg leave to return my thanks to the gentlemen who have done me the honour of electing me one of the Directors of the Society of Artists. As I have for some years past entirely declined acting as a Director I must now request the favour of declining that honour, the doing which I hope will not be understood as proceeding from any want of respect, as I have made the same request to the former set of Directors.

Some scholars think that Reynolds was aware of the plans to create a royal academy at an early date and so kept himself clear of the quarrels in the Society of Artists in order to keep his nose clean. I don't subscribe to this view. I think he was busy in his professional practice and the tone of his letter reflects his view that at this stage he did not want to take on additional responsibilities.

3 *Foundation*

Three of those who had resigned from the Society of Artists on 4 November had made an arrangement to see the King, together with a fourth, Francis Cotes, who had been criticised for his hanging policies at the exhibitions of the Society of Artists.

They were led by William Chambers. He was furious about what had happened and had a strong sense of propriety, was ambitious for himself, but also for the practice of architecture. Now middle-aged, he had been born in Gothenburg in Sweden. After a period spent as a merchant on ships sailing out to Canton, he was trained as an architect at the Ecole des Arts, a privately run art school in Paris, under its Director, Jean-François Blondel. This was unusual for anyone of his generation working in England. After a long time visiting classical sites in Italy, where he was described by Robert Adam, a fellow student and future rival, as 'a prodigy for Genius, for Sense & good taste', he had arrived in London in 1755 to establish himself as a leading architect. He was almost immediately hired as a tutor to the young Prince of Wales, who was a shy fifteen-year old. Chambers is assumed to have had conversations with the Prince about creating an academy at this period, because, in October 1759, Robert Wood, a classical scholar who had travelled widely in the Mediterranean and was an active member of the Society of Dilettanti, wrote to Lord Bute, the King's closest advisor, suggesting that Chambers should be asked to 'throw upon paper some loose hints' for a building to house an academy.

Now that the Prince had become King George III, Chambers had a much closer relationship with him than other artists. In fact, according to the account which he gave to the first meeting of the General Assembly of the Royal Academy, as recorded in the minutes, he must already have sounded out the King concerning their proposal, informing him

> that many Artists of reputation together with himself, were very desirous of establishing a Society that should more effectually promote the Arts of Design than any yet established. But that they were sensible their Design could not be carried into Execution without his Majesty's Patronage, for which they had prevailed upon him to solicit.

The second member of the group was Benjamin West, who was aged thirty, born in Chester County, Pennsylvania, the son of Quaker parents. He was tall, full of a rather arrogant self-confidence, with just a hint of the exoticism that came from being a colonial, and had a passion for history painting. He trained as a painter in Philadelphia and was then sent to study in Italy, where he improved his skills by copying Old Master paintings in the north. While in Venice in 1762 he met Richard Dalton, the King's librarian, who commissioned him to paint *Cymon and Iphigenia* for the King. This was one of the pictures that made West's reputation as a history painter when it was exhibited at the Society of Artists in 1764. Four years later, he showed another huge history painting, this one based on the writings of Tacitus: *Agrippina Landing at Brundisium with the Ashes of Germanicus*, which was commissioned by the Archbishop of York. This was so admired by the King that, in February 1768, he commissioned 'another noble Roman subject … I mean the departure of Regulus from Rome', based on Livy's account, which he read out to West. So, West, too, like Chambers, was already known to the King.

George Michael Moser was older, in his early sixties, and spoke with a strong Swiss accent. A brilliant technician, he was much admired by his fellow artists for his extreme ingenuity in the decoration

of small gold boxes and was described by the antiquarian George Vertue as 'the best workman in that way of chaseing Gold small-works, for watches boxes Trinkett etc.' Ever since he had come to London in 1726, Moser had been involved with all the attempts to establish proper facilities for the teaching of art in London, initially founding a small, private academy in Greyhound Court, off Arundel Street, near the river just east of old Somerset House; and then in an 'upper room' in Salisbury Court, further east towards St Paul's. According to the account given by his daughter Mary to Joseph Farington, whose diary is one of the best sources for the early history of the Royal Academy, Moser, together with five other foreigners, 'made up a little Academy for drawing from a living model by lamplight'. Reynolds certainly regarded him as 'the FATHER of the present race of artists'. So, he was an obvious person to have been invited to meet the King, bringing his long experience of artists' associations and a strong belief in the need for good opportunities for study and teaching.

The fourth person was Francis Cotes, known to his friends as Frank, a successful portrait painter who had made quite a bit of money and owned a large house on the south side of the recently built Cavendish Square, which not only had a gallery in which he was able to exhibit his works, but also a room in which his pupils could work and a coach house and stables at the back. He, too, had attracted the attention of the King through work he had exhibited at the Society of Artists, and he had been commissioned to make pastels of two of the King's daughters, Princess Louisa and Princess Caroline Matilda, as well as the Queen herself. At the time of his visit to St James's Palace, Cotes was suffering very badly from gallstones. In June, he had had an extremely painful operation to have them cut out.

The four brought with them a petition that had been widely canvassed among the leading artists in London and signed by twenty-two of them. All the signatories were to become foundation

members of the new academy. Joshua Reynolds did not sign because he had spent the previous two months, ever since the problems with the Society of Artists had first arisen, travelling in France with his friend William Burke, and thus was not at this stage involved with the machinations of the group. Burke was a fellow Whig, author of occasional pieces of journalism with his (putative) cousin Edmund Burke, and Member of Parliament for Great Bedwyn.

The petition began in a florid style:

To the King's most excellent Majesty:

May it please Your Majesty, We your Majesty's most faithful Subjects, Painters, Sculptors and Architects, of this Metropolis, being desirous of establishing a Society for promoting the Arts of Design, and sensible how ineffectual every Establishment of that Nature must be, without the Royal Influence, most humbly beg leave, to solicit Your Majesty's gracious Assistance, Patronage and Protection, in carrying this useful Plan into execution.

It has to be said that this was somewhat tendentious, because only fourteen years earlier the Society of Arts had been established precisely in order to promote the arts of design. But the Society of Arts had not itself taught drawing and, although it offered a number of prizes, it was essentially mercantile and utilitarian in its aspirations. In the intervening fourteen years, the influence of neoclassicism, an increasing belief that art should address grand themes of history and classical subject-matter, as well as a recognition that the Society of Arts did not pretend to look at the relationship between architecture, sculpture and painting, meant that a number of well-established artists, many of whom were immigrants from France, Italy or Switzerland, now felt that it was time to establish a proper academy on continental lines under the auspices of, and thus with the authority of, the King.

They were quite specific about what they wanted and spelled it out in the second paragraph of their petition:

It would be intruding too much upon Your Majesty's time, to offer a Minute Detail of our Plan, We only beg leave to inform Your Majesty, that, the two principal Objects we have in view are, the establishing a well regulated School or Academy of Design, for the use of Students in the Arts, and an Annual Exhibition open to all Artists of distinguished Merit, where they may offer their Performances to public Inspection, and acquire that degree of Reputation and Encouragement, which they shall be deemed to deserve.

There was nothing new about either of these proposals. Perhaps the emphasis was placed on good regulation because so few of the previous schools of design had been especially well organised and many of them had closed down quite quickly. An annual exhibition was, of course, by now also relatively well established as a way of getting works of art to be seen by the public instead of being locked away in country houses or in the private galleries of the nobility. Artists were interested in the idea that anyone who could pay a shilling could come and see pictures, particularly anyone who might be interested in buying them.

So, there was nothing particularly new in the plan that was being put to the King. What was different on this occasion was that the King was to be involved very actively in the project, not just as a distant figurehead, but as someone who was expected to be closely concerned with making and approving appointments, as a source of authority to avoid the fractiousness that had plagued all previous artists' clubs and associations, and as a way of giving kudos to the annual exhibition, sometimes described as the 'Royal Exhibition'.

The four artists ended their request by talking about money. They hoped that the profits from the annual exhibition would cover the running costs of the academy and even provide enough 'that we shall be enabled annually to distribute somewhat in useful charities'. But 'should we be disappointed in our expectations, and find that the profits of the Society are insufficient to defray its expenses, we humbly hope that your Majesty will not deem that expense

ill-applied which may be found necessary to support so useful an institution'.

So, what did the King think? In the minutes of the first General Assembly of the Royal Academy, it is recorded that 'His Majesty received them very Graciously' and went on to declare that 'he considered the Culture of the Arts as a national Concern, and that the Memorialists might depend upon his patronage and Assistance in carrying their Plan into execution'. However, he was also, rightly, cautious, probably aware that many such projects had previously foundered. So, he asked 'that their Intentions might be more fully explained to him, and that it might be done in writing as soon as was convenient'. He wanted them to avoid the ructions that had afflicted other, equivalent bodies.

George III must have been sympathetic, because he was to become the project's staunchest ally. At every single meal since, the Academicians have drunk a toast to 'our patron, protector and supporter' – that is, the reigning monarch. This is more than just a social ritual. It is a recollection of the role that George III played in the Royal Academy's formation.

Tuesday 29 November 1768

The day after the royal audience, the artists associated with the Society of Artists assembled for their monthly meeting at the Turk's Head Tavern in Gerrard Street. They were full of discontent with the fact that Chambers had resigned from the Society and were discussing what should be done about it. Thomas Jones recorded what happened next:

> After a most tumultuous Meeting at the Turk's head, where
> I was present, One of them put a stop to all the Disputes at
> once – by declaring, to our Astonishment, and mortification,
> that his M—y had given his Sanction to the establishment of
> a *Royal Academy* and under whose patronage they meant to
> Open an Exhibition in Pall Mall – Sveral Members of the first
> consequence, at the Time, inveigh'd in the strongest Terms
> against the measure who – afterwards joined them – and

Reynolds himself, in my hearing, declared that from that Day forward, he *never* meant to exhibit, but that if he did – he should exhibit with the original incorporated Body.

If nothing else, this indicates that, at this stage, Reynolds was not party to the plan to establish an academy to be a rival to the Society of Artists; indeed, he pledged his loyalty to the existing organisation.

Meanwhile, what were Chambers and his associates doing? We know from an entry in Joseph Farington's *Diary* that a number of meetings were held at Joseph Wilton's smart new house, next to his sculpture yard on Portland Street, to discuss arrangements for the nascent academy. It is worth quoting the entry in full since it provides the best evidence of the events that took place between the audience with the King and the dinner held at Joseph Wilton's house the night before the Royal Academy's official foundation on Saturday 10 December:

> West told Smirke & me that at a meeting at Wilton's where the subject of planning & forming the Royal Academy was discussed, Sir Willm. Chambers seemed inclined to [be] the *President*, but Penny was decided, that a *painter* ought to be the *President*. It was then offered to Mr Reynolds, afterwards Sir Joshua, though He had not attended at any of those meetings which were held at Mr Wilton's.

Mention is made of a number of meetings held at Joseph Wilton's house, but there is no indication of exactly who attended, besides William Chambers, Edward Penny and Benjamin West.

One person who was obviously present was Joseph Wilton (plate 16). Wilton was a close friend and ally of Chambers. Like Chambers, he was very cosmopolitan, having trained as a sculptor in the workshop of Laurent Delvaux in Belgium, before moving to Paris, where he worked in the studio of Jean-Baptiste Pigalle and had to masquerade as a Fleming in order to avoid imprisonment as an enemy alien in the Bastille during the War of the Austrian Succession. While in Paris, he was awarded a silver medal by the Académie Royale de

Peinture et de Sculpture, before travelling to Rome in 1747, where he was to stay for the next four years, working alongside French sculptors and making money by trading in casts of antique statuary. In Rome, Wilton must have had some affiliation to the Accademia di San Luca, because, in 1750, he won its gold medal for a sculpture of *Cain Killing Abel*. In 1751 he moved to Florence, where he made friends with the British consul Sir Horace Mann; went ice-skating with the young Scottish architect Robert Adam; was painted by Reynolds wearing furs; and was elected a member of the Florentine Accademia del Disegno. He became a close friend of Chambers and the two travelled back to London with Giovanni Battista Cipriani, a Florentine painter who had decided to move to London in search of commissions. Perhaps it was then that the three of them talked about the superior systems of education available to artists in France and Italy and discussed how they would like to establish an academy in London.

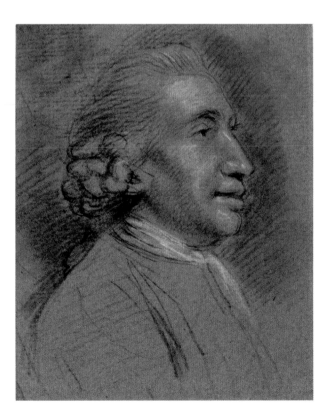

16. Attributed to Charles Grignion, *Joseph Wilton*, *c*. 1771

Once in London, Wilton was commissioned by the Duke of Richmond to supply casts for display in his sculpture gallery in his house in Whitehall, including a marble copy of the *Apollo Belvedere* to be displayed in the entrance, and, in February 1758, he was appointed one of the Directors of the drawing school that the Duke opened for boys over the age of 12. He was also, like Chambers, taken up by the Prince of Wales and supplied statues of the Muses for the Prince's gallery of antiquities at Kew. He made his reputation as a sculptor by winning the competition to design a commemorative monument to James Wolfe for Westminster Abbey and, in August 1761, he was appointed 'Sculptor in Ordinary to His Majesty'. He was also involved with Chambers in organising the Society of Artists exhibitions in Spring Gardens as a co-signatory of the rental agreement with Christopher Cock, the auctioneer.

Wilton comes across as rather smooth and a fixer behind the scenes. He was well connected in the art world and was well off because his father had made a lot of money out of a factory that produced *papier-mâché* ornaments for chimneypieces and was said to employ 'hundreds of people, including children'. Wilton, alongside Chambers, must have seen the virtues of establishing an academy that could teach a new generation of artists about the antique. He was subsequently to play a key role as Keeper of the Royal Academy and, later in life, he was portrayed by John Francis Rigaud in company with Reynolds and Chambers, mallet in hand and pointing towards a cast of the *Apollo Belvedere*.

Farington says that Edward Penny (plate 17) insisted that a painter should be President, over-ruling Chambers, who had wanted the role for himself. So, Penny was present at the meetings. In addition, at the meeting of the General Assembly on Monday 2 January 1769, Penny was thanked 'for his Activity in bringing several worthy Members into the Society'. So, he was obviously important in these early stages of forming the Royal Academy, not least in persuading members of the Society of Artists to come on board.

Like so many of those involved in the establishment of the Royal Academy, Penny had studied in Rome and wanted to leave behind portraiture for the more prestigious genre of history painting. In 1764 he had exhibited a highly innovative painting entitled *The Death of Wolfe* at the annual exhibition of the Society of Artists, a work that demonstrated how it was possible to give a subject from recent history a sense of pictorial grandeur. This was the style of painting that the Academicians should aspire to, not the run-of-the-mill routine of society portraiture.

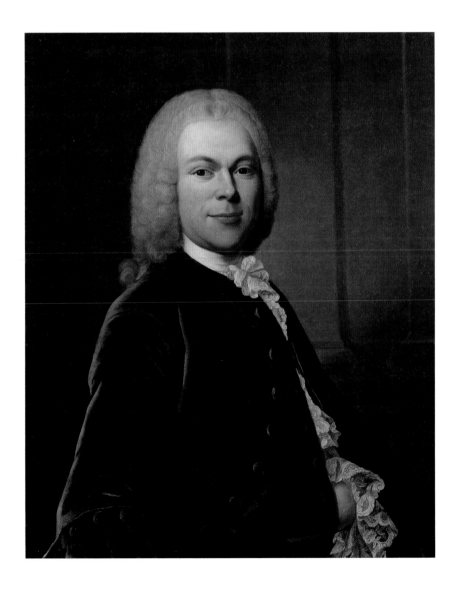

17. Edward Penny,
Self-portrait, 1759

The third person who is almost certain to have been involved in the early discussions was Francis Milner Newton (plate 18), who by now perfectly understood the mechanics of establishing an academy and had exactly the right legally inclined temperament to write its rules. Whenever there had been a previous proposal to create an academy, Newton had always been picked to act as secretary. He was the person who, in October 1753, had issued a circular to his fellow artists describing how there was 'a scheme on foot for creating a public academy for the improvement of painting, sculpture, and architecture'. The language he used in this circular is indicative of Newton's personality and his attention to detail; he thought it 'necessary to have a certain number of professors, with proper authority, in order to making regulations, taking subscriptions, &c., erecting a building, instructing the students, and concerting all such measures as shall be afterwards thought necessary'. Newton was described by the sculptor Joseph Nollekens and the landscape painter John Inigo Richards as having a narrow mind, but this narrowness of mind and interest in the minutiae of procedure were precisely what was required at this juncture.

One must imagine this group poring over who should be the members, how the academy would operate, thinking about equivalent institutions, including the Royal Society, the Society of Antiquaries, the Society of Arts and perhaps the Academy of Ancient Music, and recollecting the key elements of the Accademia del Disegno in Florence, the first of the academies to have been established in Italy, the Accademia di San Luca in Rome, which was the best known, and the Ecole des Arts in Paris, where Chambers had himself been a student.

What one realises in considering who was involved at this stage of the discussions is the extent to which the Royal Academy was derived from the experiences of a small group of artists, mostly friends, part of a younger generation who looked to the King to improve the status of art. The majority of them had trained abroad,

knew the facilities available in Paris, Rome and Florence, and wanted to replicate them in London. They knew too that there were plenty of people around in London who already had well-formulated ideas for the establishment of an academy and, indeed, had been involved in previous attempts to establish one.

Monday
5 December 1768
Thomas Gainsborough wrote from Bath to his friend Joshua Kirby to tell him that he, too, like Reynolds, was unwilling to serve as a Director of the Society of Artists: 'I thank ye for the honor done me in appointing me one of your Directors; but for Particular Reasons I beg leave to resign.' The letter could scarcely be more terse. It has always been assumed that the 'Particular Reasons' were that he had

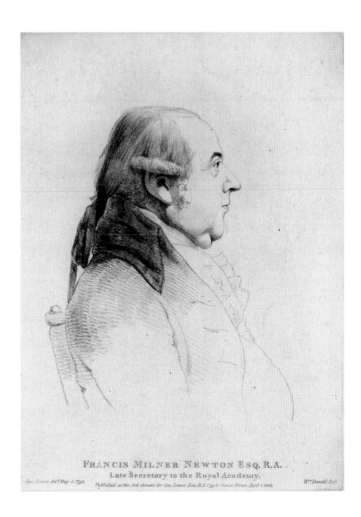

FRANCIS MILNER NEWTON ESQ. R.A.
Late Secretary to the Royal Academy.

18. William Daniell after George Dance, *Francis Milner Newton*, published 1 April 1803

just been approached to become one of the foundation members of the Royal Academy, although he was never particularly enthusiastic about that idea either.

Wednesday
7 December 1768

By now, the plans for a royal academy had been pretty well prepared and Chambers went back to see the King to describe what was proposed. According to the account given in the minutes of the first General Assembly of the Royal Academy, Chambers drew up what was described as 'a Sketch of a Plan', although there is an element of false modesty in this description, because by 10 December he and his friends and allies had formulated an exceptionally detailed and very carefully worked-out plan of exactly how the Royal Academy might operate. In addition, this plan had apparently been 'shown to as many of the Gentlemen concerned as the shortness of the time would permit and obtained their Approbation'.

The 'Sketch of a Plan' was no great work of philosophical idealism, nor was it intended to be. It was a precise, dry and highly practical description as to how the Royal Academy would operate, somewhat legalistic in its thinking about the appropriate balance of authority. It bore the hallmarks of two people: Chambers, who was determined that the new Royal Academy should not suffer from the same problems and difficulties as the Society of Artists had encountered; and the King, who, if he were to be associated with it, was determined that the Royal Academy should be workable and not prone to the disorderliness of previous artists' societies.

Chambers duly presented his plan to His Majesty 'who perused the Whole, was graciously pleased to signifie his Approbation, and directed that it might be drawn up in Form in order to be signed by him, which Mr Chambers accordingly did'.

Friday
9 December 1768

It was decided that all artists who were regarded as suitable recruits to the new Royal Academy should be invited to a dinner to be held at 6 o'clock at Joseph Wilton's house. Naturally the guests were to

include the principal artists involved – Chambers, Moser, West, Cotes, Penny and Newton – but also as many of the other artists and engravers, jobbing sculptors, teachers of art and foreign artists in London who had signed the original petition to the King as could be assembled.

But first, news had to be broken to Joshua Reynolds that Chambers and the King had decided, presumably with the support of the others involved, that Reynolds was the obvious person to be President, and indeed that he had already effectively been appointed by royal *fiat* (plate 19).

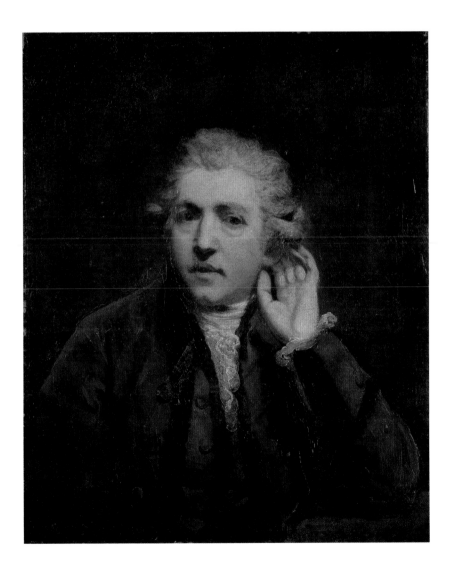

19. Sir Joshua Reynolds, *Self-portrait as a Deaf Man, c.* 1775

Edward Penny and George Michael Moser apparently went to see him, but 'failed in securing his attendance'. So, Benjamin West was sent instead. He told Reynolds that all the arrangements had been made for the new Royal Academy and that the King wished him to be its first President. But Reynolds was apparently 'still slow of belief'. According to his biographer, C. R. Leslie:

> He told West that Kirby had assured him in the most decided manner that there was no truth whatever in the rumour of such a design being in agitation; and that he thought it would be derogatory to attend a meeting constituted, as Kirby represented it, by persons who had no sanction for doing what they had undertaken. To this West answered 'As you have been told by Mr Kirby that there is no intention of the kind, and by me that there is, that even the rules are framed, and the officers *condescended* on, yourself to be President, I must insist on your going with me to the meeting, where you will be satisfied which of us deserves to be credited in this business.'

Reynolds was bullied by West into coming to the meeting, but, when offered the presidency at Joseph Wilton's house, he apparently refused to accept until he had had a chance to consult his close friends Samuel Johnson and Edmund Burke.

What made Reynolds agree?

The engraver Robert Strange maliciously suggests that Reynolds changed sides because he was won over by the promise of a knighthood and a possible commission from the King. Others too, including Thomas Jones, suggest that he was 'seduced by Titles & Honours'. It is true that Reynolds had not previously had any commissions from the King and may have wanted to be in his good books. He was not without vanity, so may indeed have been tempted by the promise of a knighthood. But his need to consult Johnson and Burke reveals that he had not already been lined up to take on the presidency, and thus, very reasonably, he wanted to give serious thought to the project, so as not to enter into it lightly.

His delay in accepting was said to have very much upset the King,

'who from that time entertained a prejudice against Reynolds, for both Johnson & Burke were then disliked by the King, the latter particularly on political accounts'. It was hardly surprising that the King mistrusted Burke at this period, since, as a loyal Rockingham Whig, Burke was a constant thorn in the flesh of the Duke of Grafton's government through the combative brilliance of his oratory.

When Reynolds gave his first Discourse on 2 January 1769, he was very careful not to claim any credit for the idea of establishing the Royal Academy, but instead congratulated his audience 'on the accomplishment of your long and ardent wishes'. At the same time, however, he acknowledged 'the numberless and ineffectual consultations which I have had with many in this assembly, to form plans and concert schemes for an Academy'.

In other words, Reynolds had been a long-term player in the many proposals to establish an academy, being both a member of the group that had met in the Turk's Head Tavern to establish one in November 1753 and, as George Michael Moser put it, 'an active, zealous, and with respect to his instruction of the students, a most liberal member' of the St Martin's Lane Academy. He had been one of the artists present at the annual dinner held in the Court Room of the Foundling Hospital in 1759, and was also an active member of the Society of Artists. He exhibited there every year, although, as we have seen, he refused to become one of its Directors in 1765, perhaps because he had recently had a minor stroke and so did not want to be involved in its formalities as an organisation, or because he sensed that trouble was brewing, or because he had recently helped to establish the Literary Club, a much more congenial group as far as he was concerned, consisting as it did of his close friends, among them Samuel Johnson, Edmund Burke and Oliver Goldsmith.

Reynolds's character made him perfectly suited to take on the role of President. Almost everyone liked and admired him. He was unusual as an artist in that he had so many friends who were writers

and philosophers, whose company he cultivated at his house (map key 9) on the west side of Leicester Fields, where he would sit late into the evening, enjoying their thoughts and encouraging free discussion, in order that, as his first biographer Edmond Malone described it, 'the honours of the turtle and haunch should give place to the feast of wit'. Almost nobody had a bad word for him, except his younger sister Fanny, who kept house for him and regarded him as a domestic tyrant.

In every other way, Reynolds was perfect: even-tempered to a fault, sociable, hard-working and conscientious. He had already greatly improved the status of painting by his commitment to it, by the quality and variety of his paintings, by his material success as an artist, and by his writings on art. Aged forty-six, with an air of benign authority, if slightly deaf, he was admirably well placed to preside over – but not necessarily to run – the new organisation.

Saturday
10 December 1768

This was the great day in the life of the Royal Academy. The Instrument of Foundation, which described in detail how the newly established institution was to operate, was 'laid before his Majesty who signified His Approbation and Ordered that the Plan should be put in execution, signing the Instrument with his own Hand'.

The Instrument of Foundation obviously bears the closest possible attention as a document, since it represents the aims and aspirations of the group of artists who had brought the Royal Academy into being at the precise moment of its inception – in other words, the core ideas that were to inform the operation of the organisation. In due course, the Instrument was to form the basis of the Laws, which still operate today.

It begins with an appropriately grandiloquent preamble:

Whereas Sundry Persons, Resident in the Metropolis,
Eminent Professors of Painting, Sculpture, and Architecture,
have most Humbly Represented by Memorial unto the King,
that they are desirous of Establishing a Society for promoting

the Arts of Design, and earnestly soliciting His Majesty's
Patronage and Assistance in carrying this their plan into
Execution; and, Whereas, its great utility hath been fully and
clearly demonstrated, His Majesty, therefore, desirous of
Encouraging every useful undertaking, doth hereby Institute
and Establish the said Society, under the name and title of the
Royal Academy of Arts in London, Graciously declaring
himself the Patron, Protector and supporter thereof; and
commanding that it be Established under the forms and
regulations hereinafter mentioned, which have been most
humbly laid before his Majesty, and received his Royal
approbation and assent.

The language echoes that of the original petition to the King.
There is a faintly legalistic aspect to it in the reference to the 'forms
and regulations hereinafter mentioned', but this was probably
because those drafting the text knew that the King was a stickler for
the rules. Central to the whole was his support and active involve-
ment as their 'Patron, Protector and supporter'.

The first paragraph reads as follows:

The said Society shall consist of forty Members only, who shall
be called Academicians of the Royal Academy; they shall all
of them be artists by profession at the time of their admission,
that is to say, Painters, Sculptors, or Architects, men of fair
moral characters, of high reputation in their several professions;
at least five-and-twenty years of age; resident in Great Britain;
and not members of any other society of artists established
in London.

This is all quite straightforward. Membership was restricted to
painters, sculptors and architects: no patrons; no collectors; no
state officials; and, contrary to the practice of other academies, no
engravers. The issue of 'fair moral character' is not exactly what was
to be expected of an artists' society, but was probably a reference to
the fact that some members of the Society of Artists were regarded as
reprobates. Hogarth's view of the world was that art was not an issue
of morality; indeed, he took the utmost pleasure in the diversity of

human temperament and regarded any attitude of moral rectitude as likely to be hypocritical. The Royal Academy was post-Hogarthian, based on the presumption that art was an expression of moral sentiments, as Edmund Burke believed. There was a sting in the tail in the requirement that membership of the Royal Academy was to be exclusive: it required its Academicians to resign both from the Society of Artists and the Free Society of Artists, the other, rival exhibiting society.

The document then described how 'It is His Majesty's pleasure that the following forty persons be the original Members of the said Society'. In fact, only thirty-six are listed, suggesting that an element of careful choice was involved and that either the full complement of members could not be identified or that a few vacancies were left to allow for election of the remaining few.

It is worth subjecting those foundation members whom we have not yet encountered to careful scrutiny, because the nature of the membership was to determine the character of the Royal Academy, not only in 1768, but in the future.

Joshua Reynolds

George Michael Moser

Benjamin West

Samuel Wale was one of the artists who had been actively canvassing for a royal academy, helping John Gwynn in the writing of his *Proposals for Erecting a Public Academy*, which was published in 1749. He was a member of the committee to set up exhibitions under the auspices of the Society of Arts, and the engraver of a vignette entitled *The Genius of Painting, Sculpture, and Architecture Relieving the Distressed*, which appeared in the catalogue of the first Society of Artists exhibition. According to Edward Edwards, Wale was 'not one of the first artists of the age in which he lived; yet it should be remembered to his

honour, that he was a man of excellent character and benevolent mind, ever ready to assist those who sought his aid or instructions'.

Thomas Sandby, a brilliant architectural draughtsman and occasional designer of buildings, had begun his career as a draughtsman to the Board of Ordnance, serving in Scotland under the Duke of Cumberland. Both he and his younger brother Paul had organised sketching classes for young artists and they were jointly responsible for producing engravings of London and fine watercolours of Windsor Great Park. The Duke of Cumberland had appointed Thomas as his steward and deputy ranger of Windsor Great Park, which meant that he was responsible for all aspects of the Park's management and finances; he lived out at Windsor with his extensive family.

Peter Toms was not a very distinguished artist, but he had worked frequently for Reynolds, Cotes and West as a drapery painter. Perhaps he had more status as a herald, as he had been appointed Portcullis Pursuivant by the College of Arms in 1746. He was quite strong-willed and too partial to the bottle.

Francis Cotes

Angelica Kauffman was an artistic prodigy, unusual in being a woman who practised history painting, and she seems also to have been something of a femme fatale, attracting the attentions of both Benjamin West and Nathaniel Dance in Italy. She arrived in London in 1766, having already established her reputation in Italy, where she was a member of the Accademia del Disegno in Florence, the Accademia Clementina in Bologna, and the Accademia di San Luca in Rome. In London, she quickly made friends with Joshua Reynolds, who painted her portrait and is thought to have been sweet on her (plate 20).

John Baker was an obscure flower painter who had been trained in his father's workshop as a coach painter and turned out to be so good at

painting the flowers around coats of arms that he ended up painting flowers alone. He was described rather snootily by Joseph Farington as having manners 'such as are seen in the inferior ranks of Society', but was acknowledged to have professional skills that caused him 'to be looked to with respect'.

Richard Yeo held the formal title of Second Engraver to the Royal Mint. Although engravers were not listed among the categories of artists considered eligible to become Academicians, his responsibilities were concerned with the design of coins, including guineas and a five-guinea piece that was never minted, and he was not a conventional printmaker. He was responsible for the official Culloden

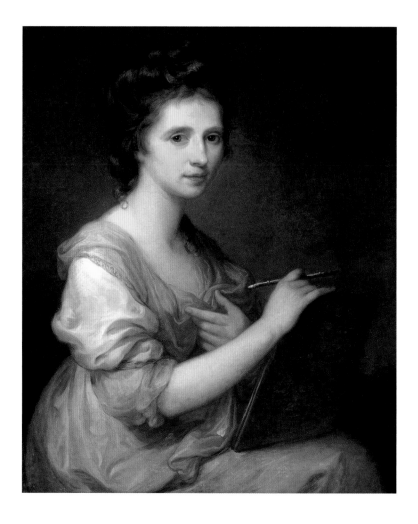

Medal, struck to commemorate the Duke of Cumberland's victory in 1746. He also produced medals for the Academy of Ancient Music in 1750 and the Chancellor's Medal for Oxford University in 1752.

Mason Chamberlin started life working in a counting house in the City, lived in Spitalfields, was said to have been a pupil of Francis Hayman, and painted in a slightly Frenchified and engagingly unpretentious style.

Mary Moser (plate 21), although she was aged only 24, was in a privileged position as the daughter of George Michael Moser and his wife Mary, whose father had been a painter at Grenoble. Their

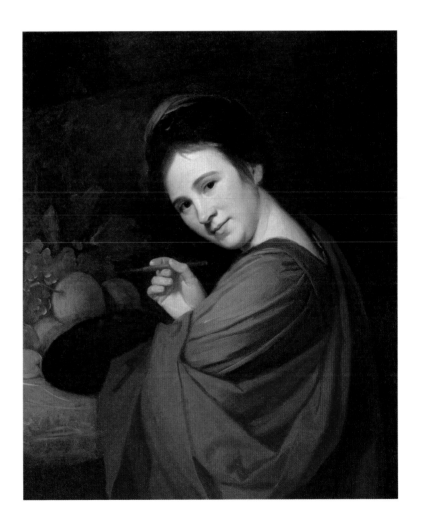

20. Angelica Kauffman,
Self-portrait, c. 1770–5

21. George Romney,
Mary Moser, c. 1770–1

daughter showed her skills early by winning a prize from the Society of Arts in the category of drawings of ornament for girls under eighteen. The following year she won a silver medal in the category of polite arts. By 1768, she was already well established as a flower painter and is said by Joseph Farington to have been drawing mistress to the young princesses.

John Gwynn was an architect and autodidact whose *Essay on Design* included *Proposals for Erecting a Public Academy*. He collaborated with Samuel Johnson on the writing of *Thoughts on the Coronation of His Present Majesty George the Third*, lived in a back street off Leicester Fields in a house designed by James Paine, and had recently published a book on town planning entitled *London and Westminster Improved*, in which he made the case for investment in public works on the grounds that they would provide employment to artists and craftsmen and bring wealth to the country.

William Chambers appears relatively far down the list. Was this a result of modesty? Not the impression the Swedish government might have received on reading a letter he wrote in 1771, in which he recorded his belief that the Royal Academy 'was planned by me and was completed through my efforts, a circumstance that affords me great pleasure, as in all probability this institution will cause the arts to rise as high as possible in this country'.

Thomas Gainsborough (plate 22) was perhaps one of the artists who was persuaded to join by Edward Penny. Conscious of the prestige attached to the new institution, he may not have wanted to be left out. He was said by Edward Edwards, one of the first students in the Academy Schools, to be 'capricious in his manners, and rather fickle and unsteady in his social connections'. This may have been why he blew hot and cold about the idea of the Royal Academy from the beginning.

Joseph Wilton

Giovanni Battista Cipriani was the Florentine painter who had made friends with Chambers and Wilton while in Rome in the early 1750s and travelled back with them to London, where he married a reasonably wealthy wife, taught at the Duke of Richmond's drawing school in Whitehall, helped design the state coach for George III's coronation, and provided ceiling paintings in buildings designed by Chambers and Robert Adam, including Buckingham House.

George Barret was an Irish landscape painter. As a student in Dublin, he had been a friend of Edmund Burke, and was now much employed by the aristocracy to paint their parks.

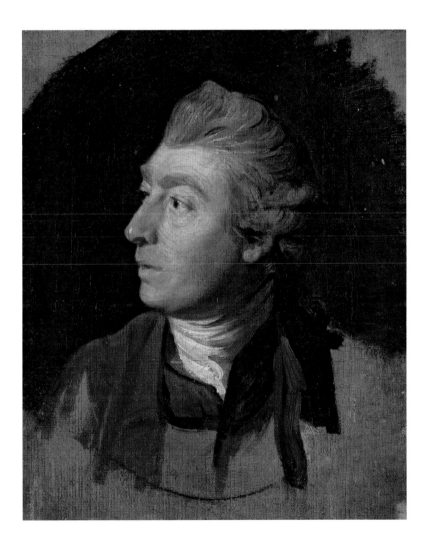

22. Johan Zoffany, *Portrait of Thomas Gainsborough, c.* 1772

Jeremiah Meyer (plate 23) was a German miniature painter who had come to London to study under the painter Christian Zincke. He is said to have imitated the work of Reynolds, and was later described as 'one of the most active, and most respected' of the Academy's earliest members.

Edward Penny

Francis Milner Newton

Agostino Carlini was a rather scruffy Genoese artist, remembered by J. T. Smith 'with a broken tobacco-pipe in his mouth, and dressed in a deplorable great coat'. Early in his career, he had done a great deal of wood carving for the palace of Het Loo outside The Hague and had

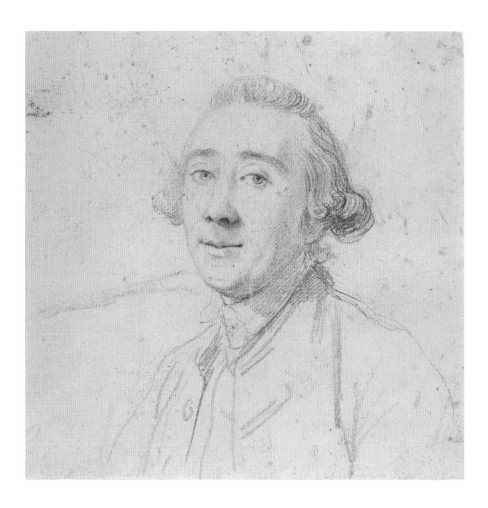

entered, but failed to win, the competition for a monument to James Wolfe for Westminster Abbey in 1760.

Paul Sandby (plate 24) was Thomas's younger brother and, like him, an extremely accomplished topographical painter. He had been involved in the mapping of the highlands after Cumberland's victory over the Jacobites at Culloden Moor, and had recently been appointed chief drawing master at the Royal Military Academy, Woolwich.

Francis Hayman was, like Moser, of a slightly older generation and, also like Moser, had lived through the multitudinous variety of previous artists' societies. He had been elected a member of the

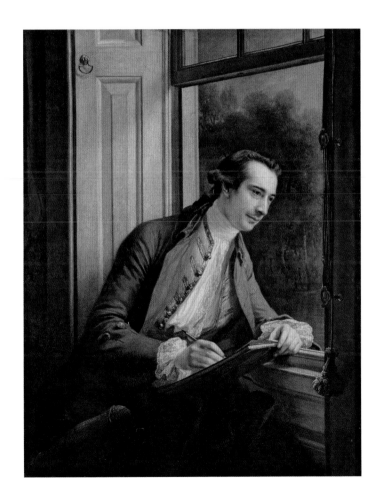

23. Jeremiah Meyer, *Self-portrait*, date unknown

24. Francis Cotes, *Paul Sandby*, 1761

Beefsteak Club in 1742, was active in promoting the St Martin's Lane Academy, and had chaired a committee of artists to establish a 'public academy' in 1753, as well as becoming, as we have seen, the first President of the Society of Artists.

Francesco Bartolozzi (plate 25) was an engraver who had been trained at the Accademia del Disegno in Florence, worked with Piranesi in Rome, and had met Richard Dalton, the King's librarian, in Bologna in 1763. Dalton had commissioned him to undertake engravings of important Old Master paintings with an annual salary of £300, much to the chagrin of Robert Strange who had wanted the

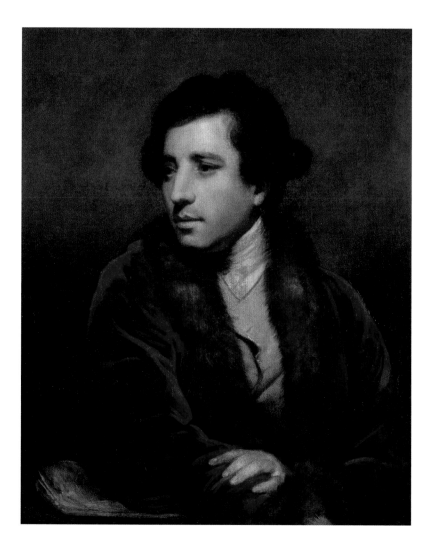

commission for himself. Dalton subsequently promised Bartolozzi appointment as 'engraver to the King' if he were to come to London, which he did, leaving his wife and their son behind. It must have been particularly annoying to engravers that, although the Academy was ostensibly not prepared to admit them to membership, Bartolozzi was among the foundation members.

Dominic Serres (plate 26) was a Gascon marine painter who had lived a surprisingly adventurous life, given his initial training for the priesthood at the Benedictine monastery of Douai. He ran away to sea, sailed to South America, and eventually became master of a

25. Sir Joshua Reynolds,
Francesco Bartolozzi, 1771–2

26. Paul Sandby, *Dominic Serres*, 1792

trading vessel in the Caribbean. Captured aboard a Spanish ship, he was gaoled at Marshalsea Prison. On his release, he established himself in a shop on London Bridge and later moved to Piccadilly, 'where, in a small shop, he exposed his pictures at the window for sale, which were mostly sea views, and sometimes landscapes'. He was certainly one of the more cosmopolitan of the early Academicians, 'a tolerable Latin scholar, spoke the Italian language perfectly, understood the Spanish, and possessed something of the Portuguese'.

Charles Catton was coach painter to George III, which was probably why he was appointed. He had worked extensively for William Chambers as well.

John Inigo Richards was Hogarth's godson. Mainly working as a scene painter at Covent Garden, he had also exhibited landscapes at the Society of Artists.

Nathaniel Hone (plate 27) was another Irishman. He had been elected a member of the Accademia del Disegno in Florence *in absentia* in 1752 and was rich enough to be free to paint subject pictures, including later in life *The Conjuror*, a scurrilous satire on the work of Sir Joshua Reynolds, whom he suggested had borrowed his compositions from the work of other artists (which was true).

Francesco Zuccarelli was known as a painter of pastoral landscapes, which had been much collected by Joseph Smith, British Consul at Venice, as well as by English *milordi* on their Grand Tours. He had lived in England for ten years, from 1752 to 1762, and returned again in 1765 when he exhibited at the Free Society of Artists. The King had recently commissioned him to paint *The Finding of Moses*.

William Tyler, a funerary sculptor, had exhibited a model for a monument to James Wolfe for Westminster Abbey at the Society of Arts in 1760 and been selected by the City of London to produce a statue of

the King for the Royal Exchange. He apparently lived 'in Dean St nearly opposite Annes Church, where his wife kept a shop and sold watch springs or something of the kind'.

George Dance was, like Benjamin West, a rising star, aged only 27, having returned from Italy in 1765. He had spent six years there studying works of classical antiquity, and had won the gold medal of the Accademia di Belle Arti, Parma, in 1763 and been admitted to the Accademia di San Luca in Rome the following year. An architect, he had recently taken over from his father as Clerk of the City Works.

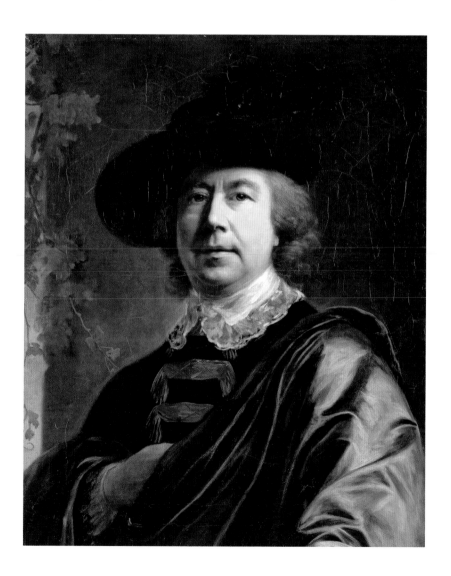

27. Nathaniel Hone, *Self-portrait*, 1768

Nathaniel Dance (plate 28) was George's older brother and had also spent a considerable time in Italy, where he worked with the Grand Tourists' celebrated portraitist Pompeo Batoni. He was commissioned by Richard Dalton to paint a full-length portrait of Edward, Duke of York, for the King, and was admitted to the Accademia di San Luca in Rome in the same year as his brother. He is known to have courted Angelica Kauffman.

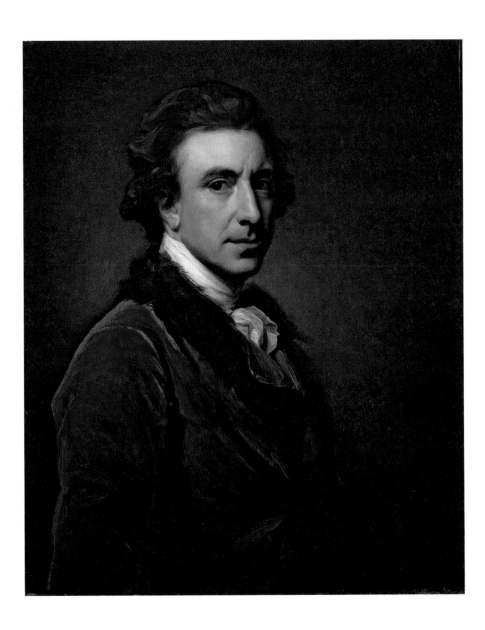

William Hoare (plate 29) worked mainly as a portrait painter in Bath, but had close links to the London art world. He was one of those involved in the attempt to found an academy in 1755, and had exhibited regularly with the Society of Artists. Like Zoffany, he was listed as a foundation member, but must have refused to join at the outset as he was only persuaded by being personally appointed by the King the following year.

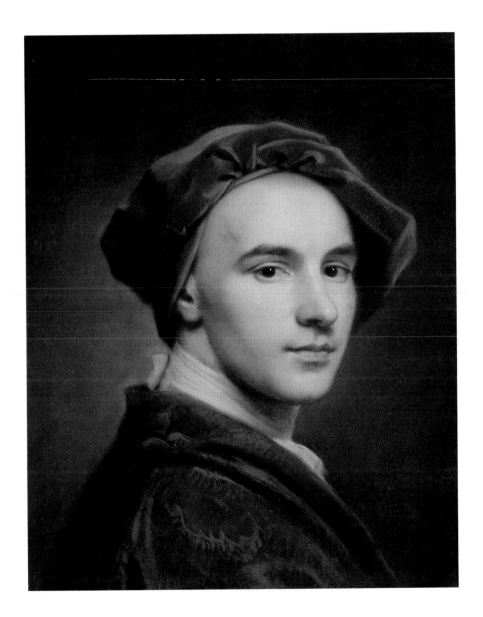

28. Nathaniel Dance,
Self-portrait, *c.* 1773

29. William Hoare,
Self-portrait, *c.* 1742

Richard Wilson (plate 30) was the leading painter of classical landscapes, had a grand studio in the north arcade of the Piazza in Covent Garden, and had caused a sensation at the first exhibition of the Society of Arts in 1760 with his painting *The Destruction of the Children of Niobe*. Chambers had tried to interest the King in Wilson's work, but without success. By the time the Royal Academy was founded, Wilson was becoming somewhat misanthropic and had hit the bottle, but he was still admired for the quality of his landscapes.

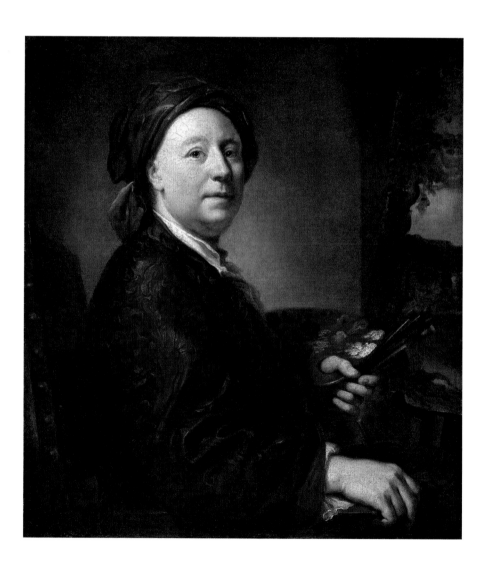

Johan Zoffany (plate 31), a German and former court painter to Johann Philipp von Walderdorff, Archbishop-Elector of Trier, was listed as one of the foundation members, although he must have refused, maybe because he was a friend of Joshua Kirby. He was only persuaded to join a year later, when, after resigning as a Director of the Society of Artists on the grounds that he was about to go abroad, he was personally appointed a Royal Academician by the King. Like so many of the other Academicians, he had spent time in Rome,

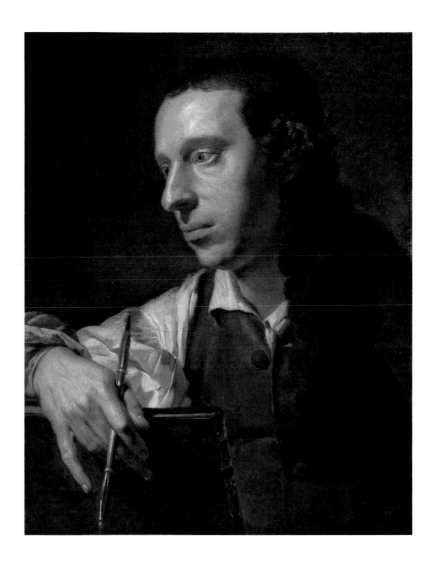

30. Anton Raphael Mengs,
Richard Wilson, 1752

31. Johan Zoffany,
Self-portrait, 1761

attending the Accademia del Nudo, which had been founded by the Pope in 1754 as a rival to the Accademia di San Luca, as well as studying under Anton Raphael Mengs, whose polished neoclassical style he imitated. After marrying, Zoffany moved to London, but his wife hated it and returned to Germany. He began by making a living as a drapery painter until commissioned by David Garrick to paint *David Garrick in The Farmer's Return*. He later developed into a fine painter of conversation pictures, and these, together with his German background, brought him into court circles and led to commissions from the King.

This line-up was not exactly the *crème de la crème* and included a surprising number of what can only be described as jobbing artists: a drapery painter (Toms), a scene painter (Richards), a coach painter (Catton) and two engravers (Yeo and Bartolozzi), a disallowed category of membership. Nor could all of them claim to be of 'fair moral character', since John Inigo Richards had recently fathered an illegitimate son by Ann Pitt, a notoriously promiscuous actress.

However, certain characteristics are common to the group. The first is the high proportion of foreign-born artists: Bartolozzi, Carlini, Cipriani (plate 32), Kauffman, Moser, Serres, Zoffany and Zuccarelli. This was an indication of the extent to which the art world in London, however determined it was to establish a native school, still deferred to those who had been trained overseas, especially in Italy. The second is the number of those who had been involved with academies in either France or Italy, including Chambers, Wilton, Reynolds, West and the two Dances. Many of them had spent time in Rome. A number were members of the Accademia di San Luca. Knowledge of the remains of classical antiquity at first hand gave them an air of authority, and friendships and rivalries that had been forged on the banks of the Tiber created a network of intellectual, as well as artistic, affiliation back in London. The third is the number who were in some way associated with the Crown, either having taught the King, like Chambers, or, like Charles Catton and Joseph

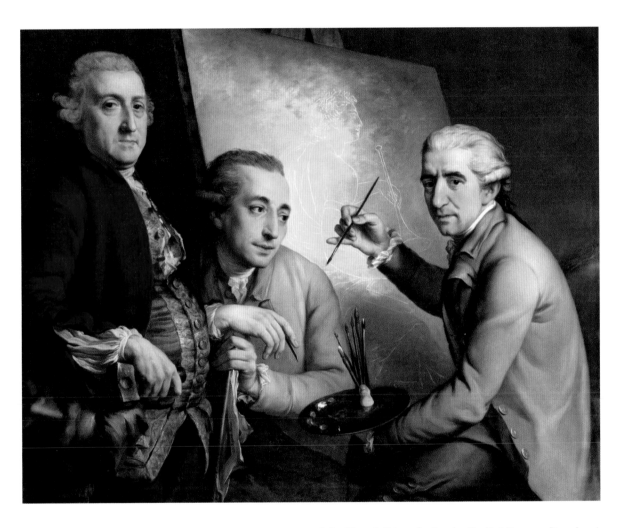

32. John Francis Rigaud, *Agostino Carlini, Francesco Bartolozzi and Giovanni Battista Cipriani*, 1777

Wilton, holding a Crown appointment, or, like Bartolozzi and Nathaniel Dance, having received commissions from Richard Dalton, the King's librarian. It is not clear if there was a political character to the Royal Academy, but it certainly helped to hold some form of public appointment, for example, to have been involved, like the Sandbys, with the army. In general, there does not seem to be any evidence that membership of the Royal Academy was political in terms of party allegiance. Instead, as the *Middlesex Journal, or, Chronicle of Liberty* observed in an attack on the Academy after its foundation, many became Academicians because they were already associated with the Crown, rather than necessarily being leaders in the arts. Their outlook was essentially cosmopolitan, and, apart from Reynolds, they had allegiances at court.

In elections to the Academy, there has often been a tendency to try to represent a diversity of media. This may have been the reason, for example, for Dominic Serres's election as a marine painter, instead of Robert Adam as another architect. Adam is the figure most conspicuous by his absence, which is always presumed to be the result of professional jealousy on Chambers's part and despite the fact that he was eminently well qualified to belong, having studied in Rome and recently published *The Ruins of the Palace of the Emperor Diocletian at Spalatro*, in which he is described on the title page as 'ARCHITECT TO THE KING AND TO THE QUEEN'. The architect Robert Mylne was also an obvious recruit, since he, too, had studied classical remains in Italy and had won the silver medal at the Concorso Clementino of the Accademia di San Luca. Perhaps he was handicapped by having beaten Chambers in the competition to design Blackfriars Bridge. As nowadays, there may have been professional jealousies at play. Allan Ramsay might have been included as one of the most well-established portraitists, who had painted the coronation portrait of the King and Queen and recently been appointed the monarch's 'Principal Painter in Ordinary'. The King, certainly, was known to have an easy relationship with Ramsay,

since he was able to converse with him in German. The painter George Romney should also have been on the list, but was probably regarded as not yet ready and too obviously ambitious. It is odd that such significant names were excluded when Reynolds's drapery painter was listed, but it is often the way with clubs that mediocre people are admitted while the character of the club is defined by the more distinguished people who are not.

Having identified the first Academicians, the Instrument of Foundation turned to the key aspects of the Academy's constitution. It began with the process of election:

> After the first Institution, all vacancies of Academicians
> shall be filled by election from amongst the exhibitors in the
> Royal Academy; the names of the candidates for admission
> shall be put up in the Academy three months before the day
> of election, of which day timely notice shall be given in writing
> to all the Academicians; each Candidate shall, on the day of
> election, have at least Thirty suffrages in his Favour, to be duly
> Elected; and he shall not receive his Letter of Admission, till he
> hath deposited in the Royal Academy, to remain there, a Picture,
> Bas-relief, or other Specimen of his Abilities, approved of
> by the then sitting Council of the Academy.

This is fairly straightforward, except for the requirement that any candidate required not a straight majority but thirty votes, i.e. three-quarters of the full membership had to vote in favour of someone for them to be elected. The system of so-called Diploma Works, whereby newly elected Academicians are required to donate an example of their output, took some time to get going and, on 9 February 1771, Council added a resolution: 'That it is proper for present Academicians to give a picture or some other specimen of their abilities to remain in the Academy.'

The next issue was the operation of Council, which was to act as the governing body:

> For the Government of the Society, there shall be annually
> elected a President and eight other Persons, who shall form

a Council, which shall have the Entire Direction and
Management of all the Business of the Society; and all the
officers and servants thereof shall be Subservient to the said
Council, which shall have the Power to Reform all Abuses,
to Censure such as are deficient in their Duty, and (with the
consent of the General Body, and the King's permission first
obtained for that Purpose), to Suspend or entirely Remove
from their Employments such as shall be found guilty of any
great Offences. The Council shall meet as Often as the Business
of the Society shall require it; Every Member shall be Punctual
to the Hour of Appointment under the Penalty of a Fine, at
the Option of the Council; and at each Meeting, the attending
Members shall receive forty-five shillings to be Equally
divided amongst them, in which Division, however, the
Secretary shall not be comprehended.

Here one sees the extreme legalism of the original foundation:
very clear in its description as to where authority was to lie; with
strong disciplinary powers, which were clearly laid out but required
the King's permission; and another disciplinary note being struck in
Council's ability to fine any of its members who did not appear at the
appointed time. These were duties not to be undertaken lightly.

Next came the system of rotation, which had caused such prob-
lems in the Society of Artists. Ironically, the Academy's was quite
a rapid system of rotation, such that half the members came off
Council every year, an issue that has remained a feature of the
institution's governance ever since, in striking contrast to the gover-
nance of, for example, an Oxbridge college, where a ruling council is
normally chosen from the overall governing body by a system of
election, in order to select those best qualified and those who want to
serve. The Academy's more random system of rotation throughout
the membership as a whole requires everyone to serve, whether or
not they are interested:

The seats in Council shall go by Succession to all Members of
the Society, excepting the Secretary, who shall always belong
thereto. Four of the Council shall be voted out every Year,

and these shall not re-occupy their Seats in the Council till all the Rest have Served; neither the President nor Secretary shall have any Vote, either in the Council or General Assembly, excepting the Suffrages be equal, in which Case the President shall have the casting Vote.

As Robert Strange commented sardonically, 'Thus what they called when *directors* "an attack upon the freedom of elections, a dangerous innovation on our charter, &c" was, in the *royal academy* deemed a just expedient and salutary measure.'

The next requirement was to describe the duties and responsibilities of the various officers, beginning not with the President, whose duties and responsibilities are nowhere described, nor the system of his election, but instead with the Secretary:

> There shall be a Secretary of the Royal Academy, Elected by Ballot, from amongst the Academicians, and approved of by the King; his business shall be to keep the Minutes of the Council, to write Letters and send Summonses, &c.; he shall attend at the Exhibition, assist in disposing the Performances, make out the Catalogues, &c.; he shall also, when the Keeper of the Academy is indisposed, take upon himself the Care of the Academy, and the Inspection of the Schools of Design, for which he shall be properly qualified; his Sallary shall be Sixty pounds a year, and he shall continue in office during his Majesty's Pleasure.

This had presumably been an easy section to write, as Francis Milner Newton had already been performing these duties as Secretary to the Society of Artists.

Next came the duties of the Keeper:

> There shall be a Keeper of the Royal Academy, Elected by Ballot, from amongst the Academicians; he shall be an able Painter of History, Sculptor, or other Artist, properly qualified. His Business shall be to keep the Royal Academy, with the Models, Casts, Books, and other moveables belonging thereto; to attend regularly the Schools of Design during the Sittings of the students, to preserve Order among them, and

to give them such Advice and Instruction as they shall require; he shall have the immediate Direction of all the Servants of the Academy, shall regulate all things relating to the Schools, and with the Assistance of the Visitors, provide the living Models, &c. He shall attend at the Exhibition, assist in disposing the Performances, and be constantly at Hand to preserve Order and Decorum. His Sallary shall be one Hundred Pounds a year; he shall have a convenient apartment allotted him in the Royal Academy, where he shall constantly reside; and he shall continue in office during the King's Pleasure.

What is interesting about this description is that the role of the Keeper was less that of a tutor in the 'Schools of Design' and more, in the literal sense of the word, a Keeper of the establishment as a whole, responsible for looking after the apparatus of the Schools and for 'Order and Decorum'. Another interesting feature of this description is that the Keeper was to be given an apartment. At the time, the Royal Academy had no premises and so George Michael Moser, who was appointed the first Keeper, was not given lodgings until the Academy was given the use of old Somerset House by the King in 1771.

The third of the officers was the Treasurer. The King insisted that it should be Chambers, so that he could remain as guardian of the Academy's financial rectitude:

There shall be a Treasurer of the Royal Academy, who, as the King is Graciously pleased to pay all Deficiencies, shall be appointed by his Majesty from amongst the Academicians, that he may have a Person in whom he places full confidence, in an Office where his Interest is concerned; and His Majesty doth hereby nominate and appoint William Chambers, Esquire, Architect of his Works, to be Treasurer of the Royal Academy of Arts, which office he shall hold, together with the Emoluments thereof, from the date of these Presents, and during his Majesty's Pleasure. His Business shall be to receive the Rents and Profits of the Academy, to pay its Expenses, to superintend repairs of the Buildings and Alterations, to Examine all Bills, and to conclude all Bargains; he shall once

in Every Quarter lay a fair State of his Accounts before
the Council, and when they have passed Examination and have
been approved there, he shall lay them before the Keeper of
His Majesty's Privy Purse, to be by him finally audited, and
the Deficiencies paid; his sallary shall be sixty pounds a year.

The emphasis on financial propriety and the more personal tone of
this paragraph suggests that it was written by the King himself in
recognition of his determination that the affairs of the Academy
should be run with due regard for economy, since he had himself
agreed to settle any debts, and his conviction that Chambers was the
most appropriate person to do this.

Having dealt with the officers, the document turned to a descrip-
tion of how the Schools of Design were to operate:

That the Schools of Design may be under the Direction of the
Ablest Artists, there shall be Elected Annually from amongst
the Academicians nine Persons, who shall be called Visitors;
they shall be Painters of History, able Sculptors, or other
persons properly qualified; their business shall be, to attend
the Schools by Rotation, each a Month, to set the Figures, to
examine the Performances of the Students, to Advise and
Instruct them, to endeavor to form their Taste, and turn their
Attention towards that Branch of the Arts for which they shall
seem to have the aptest Disposition. These officers shall be
approved of by the King; they shall be paid out of the Treasury
ten shillings and sixpence for each Time of attending, and shall
be Subject to a Fine of ten shillings and sixpence whenever they
neglect to attend, unless they appoint a proxy from amongst the
Visitors for the Time being, in which case he shall be entitled
to the Reward. At every Election of Visitors, four of the old
Visitors shall be declared non-eligible.

If the Keeper was something of a general factotum, then the
quality and character of the teaching in the Schools was to depend on
the Visitors, who were the equivalent of visiting tutors, working for a
month at a time, advising and instructing, attempting to form the
taste of the students, and pointing them in the right direction: an

admirable description of the role of a visiting tutor, then as now. With three officers, eight members of Council and nine visitors, there was not going to be a shortage of employment, and occasionally the Academy sounds as if it was devised as a system of outdoor relief for the arts in order to give painters the freedom to concentrate on history painting, rather than the more humdrum requirements of portraiture.

Next came the appointment of Professors, first among them a Professor of Anatomy, since so much stress was laid in the teaching of academies on a proper understanding of the structure of the body:

> There shall be a Professor of Anatomy, who shall read
> Annually Six public Lectures in the Schools, adapted to
> the Arts of Design; his sallary shall be thirty pounds a year;
> and he shall continue in office during the King's pleasure.

They probably had it in mind to appoint William Hunter (plate 33), the brilliant Glaswegian surgeon and anatomist who was already well known as a public lecturer. Not only was Hunter a friend of the King and physician-extraordinary to the Queen, but he was also a friend of Reynolds and had recently been appointed a Fellow of the Royal Society. He had his own anatomy theatre in his house in Great Windmill Street (map key 11), and described himself as 'pretty much acquainted with all the best artists and live in friendship with them'.

Next was the appointment of a Professor of Architecture:

> There shall be a Professor of Architecture, who shall read
> Annually six Public Lectures, calculated to form the Taste
> of the Students, to Instruct them in the Laws and Principles
> of Composition, to point out to them the Beauties or Faults of
> celebrated Productions, to fit them for an unprejudiced Study
> of Books, and for a critical Examination of Structures; his
> Sallary shall be Thirty Pounds a Year; and he shall continue
> in Office during the King's pleasure.

Presumably Chambers would have liked to be Professor of Architecture and indeed he was accidentally listed as such in a letter

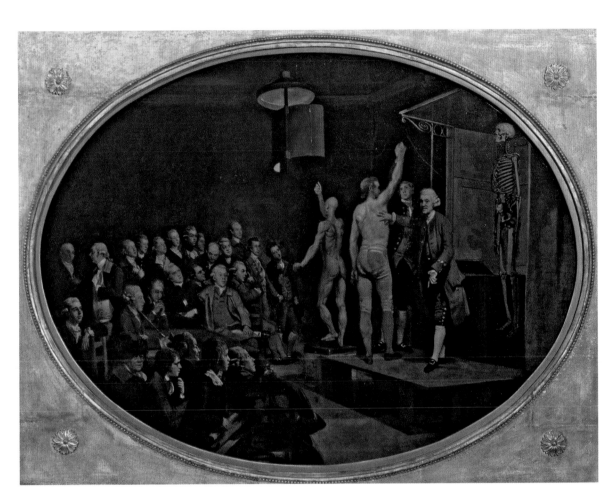

33. Johan Zoffany, *Dr William Hunter Teaching Anatomy at the Royal Academy*, *c.* 1772

Reynolds wrote to Sir William Hamilton, British Ambassador to the Kingdom of Naples, the following March. In 1759 Chambers had published his *Treatise on Civil Architecture*, which was written in order 'to cultivate taste and increase pleasure not only by providing information and examples, but also by encouraging the development of critical judgement', a wording echoed in the requirements of the Professor of Architecture. But, since Chambers was destined to be Treasurer and there was a specific enjoinder later in the document that the Academy should not encourage pluralism, Thomas Sandby was recruited instead.

Edward Penny was appointed Professor of Painting in recognition of his interest in the genre of history painting. His duties were as follows:

> There shall be a Professor of Painting, who shall read Annually
> Six Lectures, calculated to Instruct the Students in the
> Principles of Composition, to form their Taste of Design and
> Colouring, to strengthen their Judgement, to point out to them
> the Beauties and Imperfections of celebrated Works of Art,
> and the particular Excellences or Defects of great masters,
> and, finally to lead them into the Readiest and most efficacious
> Paths of study; his Sallary shall be Thirty Pounds a Year;
> and he shall continue in Office during the King's Pleasure.

Just as the description of the duties of the Professor of Architecture reflect, unsurprisingly, Chambers's views on the subject, so the description of the Professor of Painting reflects Reynolds's, with its heavy emphasis on learning from the art of the past, including 'the particular Excellences or Defects of great masters'. This was to be very much a theme of Reynolds's Discourses.

The fourth of the original Professors (not long afterwards, Professors were appointed in other fields) was a Professor of Perspective and Geometry:

> There shall be a Professor of Perspective and Geometry, who
> shall read Six public Lectures Annually in the Schools, in
> which all the useful Propositions of Geometry, together with

the Principle of Lineal and Aerial Perspective, and also the
Projection of Shadows, Reflections, and Refractions shall
be clearly and fully illustrated; he shall particularly confine
himself to the quickest, easiest and most exact methods of
Operation. He shall continue in Office during the King's
Pleasure; and his Sallary shall be Thirty Pounds a Year.

Whereas anatomy had always been a preoccupation of academies, an interest in optics was a more particular eighteenth-century phenomenon, deriving from a great interest in issues of perspective, as is evident in the writings on the subject by Hogarth, Joshua Kirby and Thomas Sandby. The King must have expected to appoint Joshua Kirby to this post, since Kirby had already been appointed by Lord Bute as 'Designer in Perspective to his Royal Highness', and was the author of *The Perspective of Architecture. A Work Entirely New; Deduced from the Principles of Dr Brook Taylor*, which was 'begun by Command of His Present Majesty When Prince of Wales' and published in 1761 with a fulsome dedication to the King. Indeed, Kirby was listed as Professor of Perspective in a letter that the two Sandbys and William Tyler wrote to Sawrey Gilpin, urging him to become an Academician. But Kirby was committed to remaining as President of the Society of Artists and, if it was ever made, he turned the offer down. Samuel Wale was appointed instead, having apparently 'a good deal of science in the accessary parts of his art', but he was a hopeless lecturer.

The lecturers had the indignity of having to submit their texts to Council for its approval, which, considering William Hunter was one of the most distinguished anatomists in Europe, may have been unnecessary, but indicates the extent to which Council expected to control what was taught:

> The Lectures of all Professors shall be laid before Council
> for its Approbation, which shall be obtained in Writing, before
> they can be read in the public Schools. All these Professors
> shall be Elected by Ballot, the last three from amongst the
> Academicians.

Having dealt with the Professors, the Instrument dealt with the other staff required – only two of them. First was a Porter:

> There shall be a Porter of the Royal Academy, whose Sallary shall be 25 Pounds a Year; he shall have a Room in the Royal Academy, and receive his orders from the Keeper or Secretary.

John Malin, who had long worked as the Porter at the St Martin's Lane Academy, was appointed Porter to the Royal Academy. To judge from the wonderful surviving drawing of him by Thomas Banks (plate 34), one of the first students of the Royal Academy Schools, he was something of a ruffian. His wife, very conveniently, became the Sweeper:

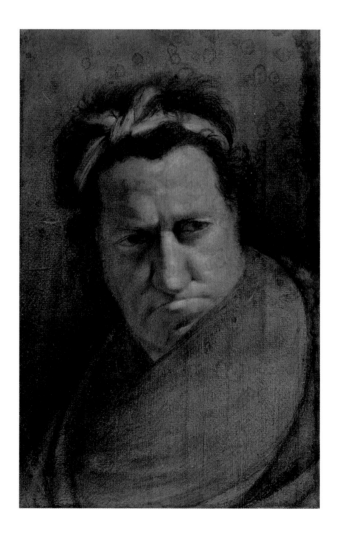

34. Thomas Banks, *John Malin* (detail), *c.* 1768–9

There shall be a Sweeper of the Royal Academy, whose Sallary shall be 10l. a year.

Next came the arrangements needing to be made for an annual exhibition:

There shall be an Annual Exhibition of Paintings, Sculptures and Designs, which shall be open to all Artists of distinguished Merit; it shall continue for the Public one Month, and be under the Regulations expressed in the By laws of the Society, hereafter to be made. Of the Profits arising therefrom, Two Hundred Pounds shall be given to indigent Artists, or their Families, and the Remainder shall be employed in the Support of the Institution. All Academicians, till they have attained the Age of Sixty, shall be obliged to Exhibit at least one Performance, under a Penalty of five Pounds, to be paid into the Treasury of the Academy, unless they can show sufficient Cause for their Omission; but after that Age, they shall be exempt from all Duty.

The operation of the Annual Exhibition merely replicated what had happened at the Society of Artists and meant that there would be not two exhibitions in competition with one another, but three, since the Free Society of Artists was already holding annual exhibitions as well.

At this point the sequence of paragraphs in the Instrument becomes slightly odd and two paragraphs are inserted that should probably have appeared earlier in the document, since they deal with the operation of the Schools. This may be symptomatic of the fact that several people were involved in the drafting of the Instrument, meaning that extra sections would have been added to the first draft in order to lay out some of the detail:

There shall be a Winter Academy of living Models, Men and Women of different Characters, under the Regulations expressed in the By laws of the Society, hereafter to be made, free to all Students who shall be qualified to receive Advantage from such Studies.

It had become obvious that there were going to have to be more detailed regulations, particularly relating to the operation of the Schools, but it was agreed that these could await the writing of bye-laws. The Summer Academy was nearly the same as the Winter, with the addition of laymen (that is, lay figures), casts and an opportunity to study flower drawing and ornament:

> There shall be a Summer Academy of living Models, to paint after, also of Laymen with Draperies, both ancient and modern, Plaister Figures, Bas-reliefs, Models and Designs of Fruits, Flowers, Ornaments, &c.; free to all Students qualified to receive Advantages from such Studies, and under the Regulations expressed in the By laws of the Society hereafter to be made.

Paragraph XX referred to the creation of a Library:

> There shall be a Library of Books of Architecture, Sculpture, Painting, and all the Sciences relating thereto; also Prints and Bas-reliefs, Vases, Trophies, Ornaments, Dresses, ancient and modern Customs and Ceremonies, Instruments of war and Arts, Utensils of Sacrifice, and all other things useful to Students in the Arts; which Library shall be open one Day in every Week to all Students properly qualified. One of the Members of Council shall attend in the Room during the whole Time it is open, to keep Order, and to see that no Damage be done to the Books; and he shall be paid 10s. 6d. for his Attendance. No Books shall, under any Pretence, be suffered to be taken out of the Library; But every Academician shall have free ingress at all seasonable Times of the Day to consult the Books, and to make Designs or Sketches from them.

This is absurdly detailed. After subordinating the detailed administration of the Summer Academy to the bye-laws, the Instrument provides a description of exactly what sorts of plates students were expected to study in the library, written by someone who had knowledge of the information students of history painting were likely to seek – perhaps Edward Penny, since he, more than

Reynolds, would have known that students of history painting would need to seek inspiration from published engravings of 'Instruments of War' and 'Utensils of Sacrifice'.

Although up until this point the Instrument has been fairly coherent, from this point onwards it becomes comparatively ragged, like a series of footnotes. First was a note about the operation of the so-called General Assembly:

> There shall be annually one General Meeting of the whole
> Body, or more if requisite, to Elect a Council and Visitors;
> to Confirm new Laws and Regulations; to Hear Complaints
> and redress Grievances, if there be any; and to do any other
> Business relative to the Society.

Since one of the things that has dogged the operation of the Royal Academy throughout its history has been the uncertain balance of power between Council and the General Assembly, just as in the Society of Artists, it is perhaps worth pointing out that, in the original Instrument of Foundation, the General Assembly met just once a year in order to elect members of Council and the Visitors and to ratify new laws and regulations. Chambers, in particular, was hardly likely to permit any ambiguity in the relationship between Council and the General Assembly, given the problems he had experienced as Treasurer of the Society of Artists. Indeed, the previous paragraph on the responsibilities of Council makes it clear that it was expected to run the operation, with only a requirement that the General Assembly ratify any changes to the Laws:

> The Council shall frame new Laws and Regulations; but they
> shall have no force, till ratified by the Consent of the General
> Assembly, and the Approbation of the King.

There is then an odd paragraph indicating that the various emoluments should be spread out as evenly as possible, rather than concentrated in the hands of a few. This is one among a number of indications that the King wanted the various salaries that were

available to act as a system of subsidy to leading members of the artistic community, rather than just benefiting the office holders:

> Though it may not be for the benefit of the Institution
> absolutely to prohibit Pluralities, yet they are as much as
> possible to be avoided, that his Majesty's Gracious Intention
> may be comply'd with, by dividing as nearly as possible the
> Emoluments of the Institution amongst all its Members.

Rather amazingly, they then considered what would happen if they needed to expel someone (amazingly because it has actually only happened twice in nearly two hundred and fifty years, once in 1799 to expel the Irish painter James Barry for his endless and intemperate criticism of the Royal Academy, and particularly of Reynolds; and a second time, in 2005, to remove Brendan Neiland for financial impropriety):

> If any Member of the Society shall, by any means, become
> obnoxious, it may be put to the Ballot, in the General Assembly,
> whether he shall be expelled, and if there be found a Majority
> for Expulsion, he shall be expelled, provided His Majesty's
> Permission be first obtained for that Purpose.

Next was a description of the appropriate requirements for admission to the Schools, which, as so much else, was in the hands of Council:

> No Student shall be admitted into the Schools, till he hath
> satisfied the Keeper of the Academy, the Visitor, and the
> Council for the Time being of his Abilities, which being done,
> he shall receive his Letter of Admission, signed by the
> Secretary of the Academy, certifying that he is admitted
> a Student of the Royal Schools.

The more one reads the document, the more one realises that there was a very clear project: to improve the quality and character of artistic training through the medium of royal patronage. They were not going to be called the Academy Schools, but the Royal Schools, an intriguing piece of nomenclature.

Then, since the minds of those drafting were on expulsion, there was a paragraph setting out how students could be removed:

> If any Student be Guilty of Improper behaviour in the Schools
> or doth not quietly Submit to the Rules and Orders established
> for their Regulation, it shall be in the Power of the Council,
> upon Complaint being first made by the Keeper of the Academy,
> to Expel, Reprimand, or Rusticate him for a certain time; but
> if he be once Expelled, he shall never be re-admitted into
> the Royal Schools.

The final paragraph of the document related to the procedure of election, which was left to the bye-laws:

> All modes of election shall be regulated by the byelaws of the
> Society, hereafter to be made for that purpose.

Considering that it had been drawn up in the space of approximately ten days, between the first visit to the King on Monday 28 November and discussion of the draft with the King on Wednesday 7 December, the Instrument of Foundation is an impressive document: clear-minded, remarkably comprehensive and demonstrating how the Academy was expected to operate in detail. Of course, those involved in drafting it up knew how academies operated in France and Italy and they are likely to have borrowed some of their features, particularly where these related to the teaching of students. They also knew that they wanted to avoid the much more ragged and quarrelsome operation of previous artists' societies in England. And they had a multitude of previous plans to draw upon, including both John Gwynn's *Essay on Design: including Proposals for Erecting a Public Academy to be supported by Voluntary Subscription (till a Royal Foundation can be obtain'd) for Educating the British Youth in Drawing, and the several Arts depending thereon*, published in 1749, and *The Plan of an Academy for the better Cultivation, Improvement, and Encouragement of Painting, Sculpture, Architecture, and the Arts of Design in General*, published in 1755. But the Instrument of Foundation,

though the product of various intelligences, does not feel like a composite document. In the clarity of its organisational thinking, it exhibits the marks of a very disciplined mind: that mind almost certainly belonged to Chambers, helped in the drafting by the long experience of Francis Milner Newton. George III approved the plan with a nice rhetorical flourish: 'I approve of this Plan: let it be put in execution.'

Twenty-eight of the thirty-six new Academicians were able to attend the ceremony at St James's Palace. Thomas Gainsborough and William Hoare were not there, because they were in Bath; Gainsborough was ambivalent about membership and Hoare had turned it down. Francis Hayman suffered from gout and, since he was not going to be President, probably felt that it was sensible to take a back seat. The two Dance brothers did not attend, for no obvious reason. Zoffany, who had been listed as one of the foundation members and was said to have promised to join, decided not to. Most conspicuous by their absence were the two female members, Angelica Kauffman and Mary Moser. They had been included unquestioningly as foundation members despite the fact that Mary Moser was aged only twenty-four (Academicians were supposed to be over twenty-five). It is odd that they were not present at the foundation ceremony.

Tuesday
13 December 1768

Word obviously got round very quickly about the nature of the new organisation and of its likely prestige, because already on the Tuesday immediately after the first Academicians had been recruited, Paul and Thomas Sandby, together with William Tyler, wrote to Sawrey Gilpin, an animal painter, urging him to lose no time in applying for membership. Gilpin was told that 'Zoffany and Mortimer have promised, and your friend Marlow now wavers in his resolution'. But Sawrey Gilpin remained loyal to the Society of Artists and was elected an Associate of the Royal Academy only as late as 1795, and a full Academician two years after that. John

Hamilton Mortimer is extremely likely to have been considered, as an exceptionally able young history painter: he had won prizes offered by the Society of Arts for history painting and had exhibited regularly with the Society of Artists. He, too, remained loyal to the Society. William Marlow, the topographical painter, did too, and was probably anyway *persona non grata* as he was one of the rebels who had made life difficult for the Directors of the Society of Artists. Following the split between the Directors of the Society of Artists and its membership, many of those artists who had not been involved remained loyal to the existing organisation. They may not have seen any reason for creating an alternative. They may have felt that the Society of Artists, which had a more open membership, was more democratic. And they may have been suspicious of the extent to which the new organisation came under the direct authority of the King.

Wednesday 14 December 1768

Someone – presumably either William Chambers or Francis Milner Newton – must have realised immediately after the meeting at St James's Palace that there was no guarantee that the newly elected Academicians would actually follow the terms of the Instrument of Foundation and that there was a risk that, as had happened with the Society of Artists, the newly established Royal Academy would descend into fractiousness. So, they devised a pledge of loyalty, which was called the 'Obligation', and they required everyone to subscribe to it at a meeting of the so-called General Assembly at Lambe's Auction Rooms.

This meeting opened with a report from William Chambers as to what had happened so far, which was recorded in the minutes taken by Francis Milner Newton and still provides the best documentary record of the sequence of events.

The meeting then broke up and immediately reassembled. The Instrument of Foundation was read out to the Academicians, followed by the 'Obligation', which made clear their duty of obedience to 'all the Laws and Regulations':

London December 14th. 1768

His Majesty having been gracious pleased to institute and establish a Society for promoting the Arts of Design, under the Name and Title of the Royal Academy of Arts in London, and having signified his Royal Intention, that the said Society should be established, under certain Laws and Regulations, contained in the Instrument of the Establishment, signed by His Majesty's own Hand.

We therefore whose names are hereunto subscribed, either Original, or Elected Members, of the said Society, Do promise, each for himself, to observe all the Laws and Regulations contained in the said Instrument, as also, all other Laws, By-Laws, or Regulations, either made, or hereafter to be made, for the better Government of the above mentioned Society. Promising furthermore on every Occasion, to employ our utmost Endeavours to promote the Honor and Interest of the Establishment, so long as we shall continue Members thereof.

As a pledge of loyalty, the Obligation has a biblical aura to its wording and is much more sonorous in its cadences than the Instrument of Foundation. Having dealt with the technicalities as to how the Academy was to operate, the Obligation was a way of conveying the more profound responsibilities of its members. It has on many occasions crossed my mind that it may be similar to a Masonic ceremony of induction. I have no evidence for this, only an awareness that Freemasonry was a very prominent movement at this period of the Enlightenment; that it requires an oath of new members; that it has some of the same characteristics in creating a secular ceremonial; that both the new Royal Academy and the Freemasons were committed to 'supporting brethren in need'; that during the 1760s, which was the high noon of an interest in the antique, there would have been artists, and particularly architects, who would have shared with the Freemasons a belief in the wisdom of the ancients; and that a number of people involved in the establishment of the Royal Academy, if not Freemasons already, were recruited during the following decade. These included Zoffany, Thomas Sandby, who was to design

Freemasons' Hall in Great Queen Street while serving as Grand Architect of the Premier Grand Lodge, and Cipriani and Bartolozzi, who were responsible for the frontispiece to James Anderson's *Constitutions of the Antient Fraternity of Free and Accepted Masons*, published in 1784.

Once the Obligation had been read out, everyone present was required to sign their names to its terms, which had been written out in advance, probably by Newton, on a large piece of vellum. Joshua Reynolds was the first to add his signature. It is still a requirement of all newly elected Royal Academicians that they sign in recognition that they have agreed the terms of the Obligation, after it has been read out by the Secretary (plate 35).

Reynolds was then confirmed as President. George Michael Moser was elected Keeper. Chambers had already been appointed Treasurer by the Instrument of Foundation. Members of Council were elected, as were nine Visitors to teach the students.

Saturday 17 December 1768

Another meeting of the General Assembly took place to elect the Professors. This was the first time that the Academy appears in the little pocket books in which Reynolds listed his appointments: he simply jotted down that at 6 o'clock he was due at the 'Academy'.

Sunday 18 December 1768

Reynolds and Chambers reported to the King at St James's Palace at half past nine in the morning (again Reynolds notes the appointment in his pocket book) and 'presented the List of the Officers, Council, Visitors and Professors to His Majesty' for his approval, 'who was most graciously pleased to signifie His Approbation of the said List, by his Sign-Manual'.

35. (*overleaf*)
The Roll of Obligation (detail)

furnithmore, in every occasion, to en...

dec: Joshua Reynolds dec: Tho...

dec: William Chambers dec: George ...

Benjamin West Paul ...

dec: William Tyler dec: Mason ...

Nath. Hone dec: Fran: ...

dec: Edw. Penny dec: Ago...

F. Hayman Georg...

dec: William Hoare Edward ...

William Peters dec: John ...

John Francis Rigaud dec: Tho...

James Northcote dec: N...

our utmost endeavours, to promote the honour and

Coles Jos. Joseph Wilton.

d Most bd. Jeremiah Meyer

nathy dy. John Baker

amberton Francesco Bartolozzi

accarelli dec: Dominick Serres.

o Carlini dec: Francis Milner Newton.

Dance bd. Tho. Gainsborough

Penny B. Vosvaig

 R. by James Barry &c.

Bartlett James Wyatt

 dec: John Russell

The first meeting of Council was held, with Reynolds in the chair as President, presumably then as now with the Treasurer seated on his right and the Secretary on his left. The other members attending were 'Messrs. Edward Penny, Francis Cotes, Joseph Wilton, Jeremiah Meyer, Paul Sandby, and Nathaniel Hone'. George Barret was also a member, but was not able to be there. It was a fairly predictable group, including Penny, who had been instrumental in persuading a number of artists to join; Cotes and Wilton, who had attended the King for the first meeting to discuss the project; and Meyer, who was later said to have been very active. Paul Sandby and Nathaniel Hone were perhaps less obvious choices. There was not a great deal of business transacted at this first meeting other than to agree 'the Rules & Orders'; it was resolved 'That Elizabeth Malin be allowed five Pounds over & above her Sallary for an Assistant' and 'That there be no Female Model for the Present'.

As Council was meeting, an article appeared in *Lloyd's Evening Post*, which described the Royal Academy in terms that mostly simply replicated the wording of the Instrument of Foundation:

> His Majesty, ever ready to encourage useful improvements,
> and always intent upon promoting every branch of polite
> knowledge, hath been graciously pleased to institute in this
> metropolis, a Royal Academy of Arts, to be under his Majesty's
> own immediate patronage, and under the direction of forty
> artists of the first rank in their several professions.

It confirmed the fact that entry to the Schools would be free and suggested that the King had allocated a house near Lambe's Auction Rooms in Pall Mall to be used by the Schools and to house the Keeper:

> The admission to all these establishments will be free, to all
> students properly qualified to reap advantage from such studies
> as are there cultivated ... and his Majesty, hath for the present,
> allotted a large house in Pall-mall for the purposes of the
> Schools, &c.

It also acknowledged the charitable purposes of the Academy:

> But as all men who enter the career of the Arts are not equally
> successful, and as some unhappily never acquire either fame or
> encouragement, but after many years of painful study, at a time
> of life when it is too late to think of other pursuits, find
> themselves destitute of every means of subsistence; and as
> others are, by various infirmities incident to man, rendered
> incapable of exerting their talents, and others are cut off in the
> bloom of life, before it could be possible to provide for their
> families: His Majesty, whose benevolence and generosity
> overflow in every action of his life, hath allotted a considerable
> sum, annually to be distributed, for the relief of indigent
> Artists, and their distressed families.

Friday
23 December 1768

Council met again to discuss the detailed 'Rules & Orders'.

Tuesday
27 December 1768

Another meeting of Council was held, in which a great deal of business was transacted. First, it was 'Resolved, That Mr William Bunce be appointed Printer to the Royal Academy' and 'That Mr Wm. Randall be appointed Stationer'. Next it was agreed:

> That those Students who have already paid their Subscription
> to the Old Academy in Pall Mall, shall be admitted into the
> Royal Academy to draw this Season, till the Expiration of
> the Winter Academy, After which Time they shall be subject
> to the same Regulations as prescribed for the Admission of
> other Students.

> Resolved, That those Students who have neglected to pay
> their Subscriptions to the Old Academy, shall not be admitted
> to draw in the Royal Academy, till they have gone through the
> usual Forms of Admission.

Then, it was decided 'That Dr Wm. Hunter (as Anatomy Professor) have free access to all General Assemblys'.

Meanwhile, more work had been done on the 'Rules and Orders', outlining many aspects of the detailed procedure of meetings,

including the fact that it was 'Resolved that The President shall have Power to summon the Council and General Assemblys of the Academicians as often as he shall judge it necessary', that 'The President shall have Power to nominate One of the Council, to act as President in his Absence' and that 'The President or his Deputy, and no other Person shall have Power to summon either the Council or General Assembly'.

Much of what was discussed consisted of a boring, but necessary, attention to due process, including, for example, the way in which Members could object to any proposed Law:

> If at a General Assembly of the Academicians, five Members
> object to any Law, By Law, or Regulation made in the Council
> for the Government of the Society, they shall deliver their
> Objections in Writing, signed with their respective Names,
> which done, the Law, or Regulation, objected to, shall be
> referred to the Council, to be reconsidered.

Much more significant was the fact that this was the meeting that agreed the detailed operation of the so-called Royal Schools, by approving 'Rules and Orders relating to the Schools of Design'. These included the exact function of the Visitors, that admission into the Schools was to be by presentation of a drawing after a cast, that the Keeper was responsible 'for preserving Order and Decorum in the Royal Schools', that 'The Winter Academy of Living Models, shall begin at Michaelmass, and end on the Ninth of April' and that 'The Summer Academy of Living Models, shall begin on the Twenty sixth Day of May, and end on the last Day of August'.

Most interesting is the description of the arrangements for the hiring of models. There were to be two of them, each to sit three nights a week 'and continue in the Attitude, two hours, (by the hourglass) exclusive of the time required for resting'. Since for much of the year drawing had to be done during dusk or during the Winter Academy, sometimes in the dark, there was a necessary requirement that it should be done by candlelight, with rules stipulating that

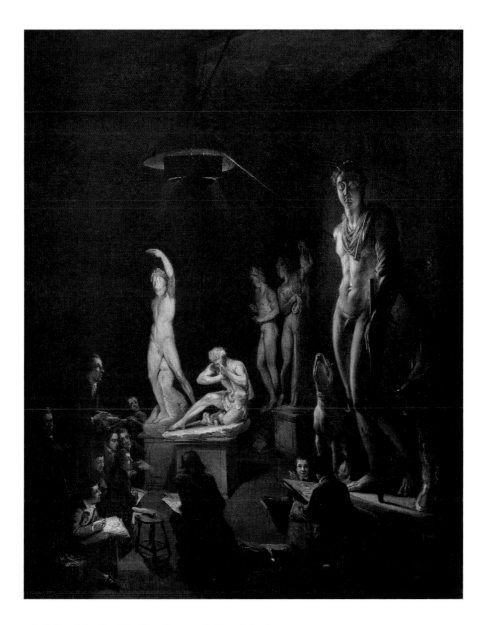

36. Elias Martin, *The Cast Room at the Royal Academy*, 1770

'As soon as any Student hath done Drawing or Modeling, he shall put out his Candles, and while Drawing or Modeling, he shall be careful to keep them under the bells.'

Alongside the life room was the cast room (plate 36), where students were to draw casts from the antique:

> There shall be Weekly, set out in the Great Room, One or more Plaister Figures by the Keeper, for the Students to draw after. And no Student shall presume to move the said Figures out of the Places where they have been set by the Keeper, without his Leave first obtained for that Purpose.

> When any Student hath taken Possession of a Place in the Plaister Academy, he shall not be removed out of it till the Week in which he hath taken it is expired.

> The Plaister Academy, shall be open every Day (Sundays and Vacation times excepted) from Nine in the Morning till three in the Afternoon.

The discipline of the Schools required an ability to draw from the antique. New students drew, day after day, from the collection of plaster casts that Moser had brought from the St Martin's Lane Academy until such time as they were thought able to submit a drawing for the approval of Council, at which point they graduated to working from the living model.

Friday
30 December 1768

Council met again and 'Resolved That the several Laws & Regulations which are now confirm'd by the Council, be laid before the General Assembly of the Academicians for their consent'.

4 *The First Three Months*

Monday
2 January 1769

Joshua Reynolds, who noted in his pocket book that it was the day of the 'Opening of the R. Academy', stood up at the lectern in Lambe's Auction Rooms in Pall Mall and read out the first of his annual Discourses in a low voice. His delivery was marred by the fact that he had damaged his upper lip in a fall from a horse while staying in Minorca, and so did not articulate what he said very well. He was also somewhat deaf, and still had traces of a Devonshire accent. We tend to think of his Discourses as a general statement of eighteenth-century artistic beliefs, but it is worth thinking about them as they were first delivered, as attempts by the newly elected President to lay down the key principles that the Royal Academicians should observe in the running of their newly established institution. He had only had about two weeks in which to write down what he thought, and is known anyway always to have worked at the last minute, writing out his ideas freehand, correcting them with numerous deletions, and then getting his only pupil at the time, Charles Gill, the son of a Bath pastry cook, to prepare a fair copy. What Reynolds said must represent the accumulation of ideas and beliefs that he had developed over the course of his lifetime as a practitioner, but also as someone who liked discussing ideas with his friends in the Literary Club and had previously been persuaded to contribute his thoughts on painting to *The Idler*.

He began by reminding his audience about the differences between the Royal Academy and the more mercantile Society of Arts:

> An Institution like this has often been recommended upon considerations merely mercantile: but an Academy, founded upon such principles, can never effect even its own narrow purposes. If it has an origin no higher, no taste can ever be formed in manufactures; but if the higher Arts of Design flourish, these inferior ends will be answered of course.

In other words, the Academy had not been founded for utilitarian purposes; it did not exist simply to improve the quality and character of British manufactures; it had higher ends, as was implied immediately afterwards when Reynolds described the King as being 'the head of a great, a learned, a polite, and a commercial nation'. It is obvious that Reynolds was seeking to bolster the greatness of the nation as a place for scholarship, the arts and learning, rather than its purely commercial requirements.

Reynolds (plate 37) argued that the principal requirement of an Academy was that

> beside furnishing able men to direct the Student, it will be a repository for the great examples of the Art. These are the materials on which Genius is to work, and without which the strongest intellect may be fruitlessly or deviously employed. By studying these authentick models, that idea of excellence which is the result of the accumulated experience of past ages, may be at once acquired.

In fact, contrary to Reynolds's wishes, the Royal Academy was never to acquire a systematic collection of original works of art for students to learn from, other than Diploma Works, which were not used for the purposes of teaching in the Schools, and occasional works that came into its possession apparently rather haphazardly, such as the Leonardo Cartoon, now in the National Gallery, which must have been given some time in the 1770s by the collector Robert Udney, who had acquired it from his brother John, the former British

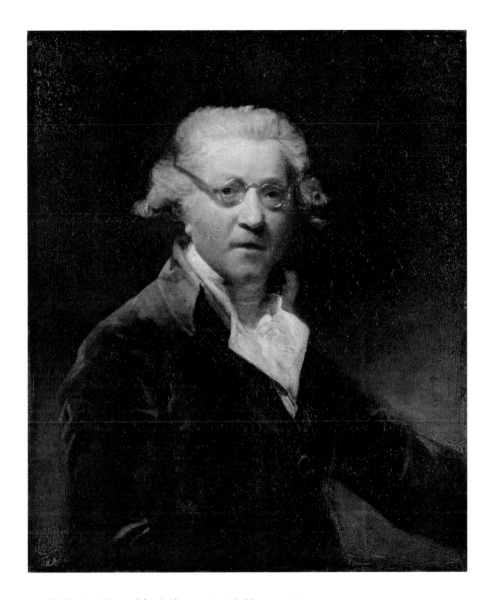

37. Sir Joshua Reynolds, *Self-portrait with Glasses*, 1788

Consul in Venice. Both Reynolds (and, after him, James Barry) very much hoped that the Royal Academy would become home to a collection of Old Master paintings that might act as (or, over time, become) a national gallery, equivalent to the galleries then being formed out of princely collections in Germany. But this never happened. The Academicians turned down the offer of Reynolds's own collection when he offered it for sale to them in 1791 and they did not succumb to the temptation of buying the Orléans Collection when that came up for sale in 1798, although they were encouraged to do so by James Barry. But copying, learning from the art of the past, drawing from casts of antique sculpture, was central to academic practice from the beginning. Nowadays, this would be regarded as outdated. But how does one learn to draw? There is surely an element of practice, detailed observation and learning from example, even now. In the eighteenth century, it was felt that the more you drew from the antique, the more you were likely to imbibe the lessons of the greatest works of art of the past. It is a statement that one can learn as much through patient observation and analysis of works of art from the past as one can from searching into the wells of one's own artistic imagination. As David Hockney has recently reminded us, art is as much about looking and description as it is about independent expression and ideas.

The second lesson that Reynolds teaches is to be suspicious of individual genius. 'Every opportunity', he writes, 'should be taken to discountenance that false and vulgar opinion, that rules are the fetters of genius. They are fetters only to men of no genius; as that armour, which upon the strong is an ornament and a defence, upon the weak and mis-shapen becomes a load, and cripples the body which it was made to protect.' He does not want students to develop too great a facility. 'At that age it is natural for them to be more captivated with what is brilliant than with what is solid, and to prefer splendid negligence to painful and humiliating exactness.' What Reynolds wants from students is hard work and no dissipation.

The third lesson that Reynolds teaches in his first Discourse is the requirement of exact observation:

> I must beg leave to submit one thing more to the consideration
> of the Visitors, which appears to me a matter of very great
> consequence, and the omission of which I think a principal
> defect in the method of education pursued in all the Academies
> I have ever visited. The error I mean is, that the Students
> never draw exactly from the living models which they have
> before them.

Reynolds's Discourses convey the intellectual precepts by which the Royal Academy Schools were to operate: the belief that art is a discipline that can be learned by the training of the hand, the eye, and – perhaps most of all – the mind, by the careful observation of works of art of the past, by drawing from the model, and by learning not only from one's teachers but also from one's fellow students.

The Discourse clearly made a great impression on its audience. It was just what the Academicians expected from their President – careful, authoritative and judicious, based on his long experience of the practice of art and an equally strong interest in its history. Reynolds was anti-genius, which was probably a way of disparaging the ideas of the young Turks in the Society of Artists. His Discourse was, as it was described in the vote of thanks, 'Ingenious, useful and Elegant' and a small number of copies were printed shortly afterwards by William Bunce.

Once Reynolds had given his address, the General Assembly moved on to other business:

> Resolved, That the Thanks of the General Assembly of the
> Academicians be given to Mr Chambers for his Active and able
> conduct in planning and forming the Royal Academy.

> That the Thanks of the General Assembly of the Academicians
> be given to Mr Penny for his Activity in bringing several
> worthy Members into the Society.

> That the Thanks of the General Assembly of the Academicians

be given to Mr Reynolds for his Ingenious, useful and Elegant Speech deliver'd at the Opening of the Royal Academy.

Ordered, That with Mr Reynolds's permission, the same be printed for the Use of the Academy.

They ended by agreeing the bye-laws discussed by Council.

Afterwards, they all repaired to St Alban's Tavern (on the corner of Charles Street and St Alban's Street) for a drink with some of their patrons and what was described in the newspapers as 'an elegant entertainment'. We don't know what they had to eat, but on a previous such occasion organised by the Society of Artists at the Turk's Head Tavern, the company had sat down to a first course of cod's head and sauce, stewed carp, soles and whitings, followed by marrow pudding, fowls, geese, veal pie, salad, beefsteak pie, greens and carrots, and fried soles and ham. They are unlikely to have had less than this.

After dinner, they sang songs, including a song entitled 'The Triumph of the Arts', which had been especially written for the occasion. It celebrated their new-found freedom to study the arts in Britain:

> Behold! A brighter train of years,
> A new Augustan age appears,
> The time, not distant far, shall come,
> When England's tasteful youth no more
> Shall wander to Italia's classic shore;
> No more to foreign climes shall roam,
> In search for models better found at home.

Saturday
7 January 1769

Council met and ordered that all the 'Rules and Orders' that had been drawn up should be made available to George Michael Moser, the Keeper, who was not a member of Council. They added some more, including a requirement that he should keep a list of the Visitors' attendance and give them a set of rules concerning what was expected of them.

Having made arrangements for female models to attend the drawing school, they now added a requirement for male models as well:

> That four Male-Models, of different Characters be provided by
> the Keeper and Visitors, each Model to receive five Shillings a
> Week as a retaining Fee, and to have the additional Pay of one
> Shilling each Night they are employed.

Having dealt with a great number of issues relating to the detailed management of the Schools, they now turned their attention to the arrangements for the Annual Exhibition. Copies were not to be allowed. Council was to be in charge of all aspects of the arrangements, including the hang. All pictures were to be framed. Nobody was to be allowed into the Exhibition Room before it had officially opened (this was to avoid artists' objections to the way their pictures had been hung). Pictures were to be submitted at the time appointed, and none would be accepted if delivered late.

Tuesday
10 January 1769

Joshua Kirby had been to see the King to discover his attitude towards the Society of Artists following the establishment of the Royal Academy. He was able to report to his members that 'his Majesty's *principal object* is the *Royal Academy*, but that He will *encourage, without distinction every Society* for ye promoting and advancing of the *liberal arts*; therefore our body will not be deprived of his Majesty's protection'.

Thursday
19 January 1769

At a meeting of Council, there was further discussion about the detailed arrangements for the Academy's first Annual Exhibition. It was planned that pictures should be submitted 'on 13th & 14th of April next, and that no Performance be received after six oClock in the Evening of the 14th of April'. Council decided that its members would all meet the following day to assess the work that had been submitted, and that the exhibition should open 'on the 24th of April, for the Royal Family & on the 26th for the Public'.

Meanwhile, they had obviously been discussing what to do about engravers, who were an important category in the practice of art and who had clearly been asking if they were to be admitted. A new category was invented for them of 'Asociate':

> That a Number of Engravers not exceeding Six, shall be admitted Asociates of the Royal Academy.
>
> That each Candidate having before produced a specimen of his Abilities shall be elected by Ballot of the whole Body of Academicians.
>
> That each Candidate shall have thirty suffrages in his favour.

The Associates were not to be officers or members of Council and did not have a vote in the General Assembly, 'but in other respects they shall enjoy all the Advantages of Academicians', including the opportunity to exhibit two prints in the Annual Exhibition.

A hanging committee was appointed, comprising Edward Penny, Paul Sandby and George Barret.

Monday 30 January 1769

There was more work to be done on the arrangements for the Annual Exhibition. It was agreed, for example, 'That all Exhibitors in the Royal Exhibition (tho: they be not Academicians) shall have free Admittance during the whole time of the Exhibition.' It was agreed that, as for the Society of Artists, there should be a preface to the exhibition catalogue apologising 'for our taking Money' (they charged 1s.) and that this preface should be written by the President.

The Keeper 'reported that, as had been agreed, four Male Models had been engaged', and he then 'presented several Drawings done from the Plaister Casts in the Royal Academy'. Immediately after this, the first students were admitted.

Edward Edwards (aged 30; plate 38) was hardly in his first youth. The son of a chairmaker from Shrewsbury, he had started life as a pattern drawer for William Hallett, the very successful cabinetmaker whose

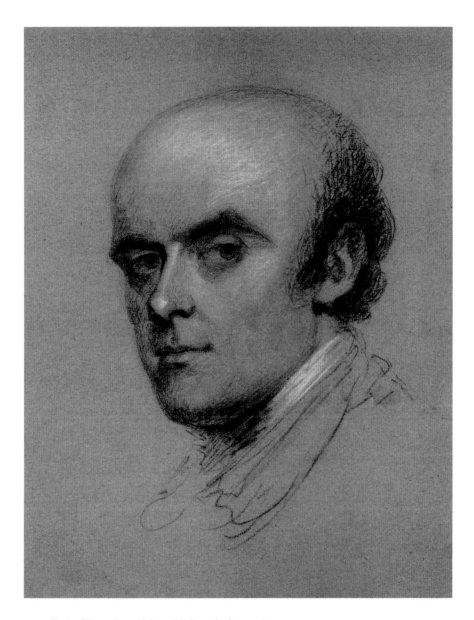

38. Ozias Humphry, *Edward Edwards*, date unknown

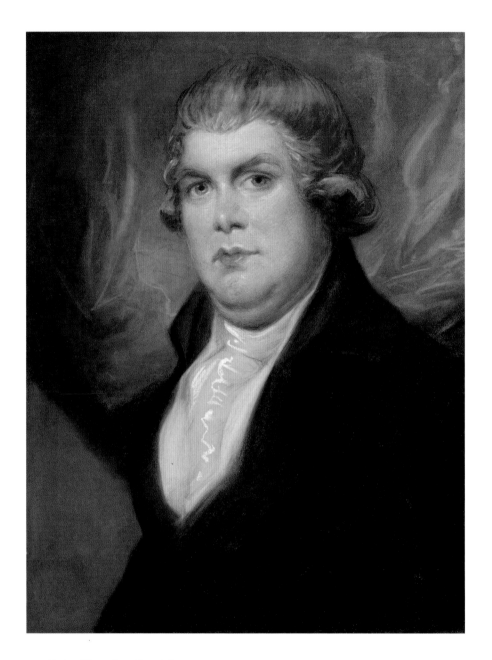

39. Ozias Humphry, *Joseph Strutt*, 1791–7

premises were at the junction between Long Acre and St Martin's Lane. Edwards had aspirations to become a history painter, having studied at William Shipley's drawing school, then as a student at the Duke of Richmond's drawing school in Privy Garden, Whitehall, and, from 1761, at the St Martin's Lane Academy. In 1764, he exhibited *The Death of Tatius* at the annual exhibition of the Society of Artists, for which he won a prize from the Society of Arts 'for the best historical picture in chiaroscuro'. Thereafter he was associated with the Society of Artists, despite being, as he himself described it, 'disgusted with the factious proceedings which prevailed in it'. He had himself already run a small evening class for artisans to learn to draw in his lodgings in Compton Street in Soho.

Biagio Rebecca (aged 34) was Italian. Born near Ancona, he had already been a student at the Accademia di San Luca in Rome, where he had made friends with Benjamin West, before coming to London in 1761.

Thomas Burgess (age unknown) had, like Edward Edwards, been a student at the St Martin's Lane Academy and had shown for several years at the Society of Artists.

Joseph Strutt (aged 19; plate 39) was the son of an Essex miller. After attending King Edward VI School, Chelmsford, he had been apprenticed to the engraver William Wynne Ryland in 1764. Strutt must already have been developing strong antiquarian interests because he had been commissioned to provide illustrations for a book about Essex antiquities by Foote Gower, a local clergyman.

William Bell (aged 33), the son of a Newcastle bookbinder, was a *protégé* of the Delavals, the local landowners at Seaton Delaval.

William Singleton (age unknown) was a pupil of Ozias Humphry, the miniature painter.

This list demonstrates that the so-called Royal Schools were not schools in the way we would regard them, but more a place for young artists who had commonly served their apprenticeship and now wanted to receive further free tuition and an opportunity to improve their drawing skills.

Not only were the Schools getting going, but the gradual making of a collection was underway. Francis Milner Newton was instructed to write on behalf of the President and Council to the 2nd Earl of Bessborough, a Trustee of the British Museum, patron of Chambers and Wilton and a prominent Irish Freemason, to thank him for the gift of two drawings, described in the minutes as 'models', one by Nicolas Poussin and another by Laurent Delvaux. He was also to write in his own name to Robert Adam and the engraver Thomas Major to thank them for their gifts. Adam had presented a handsomely bound copy of his *The Ruins of the Palace of the Emperor Diocletian at Spalatro*, which had been published in 1764 and was accompanied by a letter addressed to William Chambers in which

> Mr Adam presents his Compliments to Mr Chambers & sends
> him a Copy of The Ruins of Dioclesians palace at Spalatro
> which he begs Mr Chambers will do him the Honour to present
> to the Royal Academy & Beg their Acceptance of it, and of his
> Sincere wishes for the prosperity of so Great & so Usefull an
> Institution.

Thomas Major, Engraver to His Majesty and another potential candidate (he was the first engraver to be elected as an Associate), had given his *The Ruins of Pæstum, Otherwise Posidonia, in Magna Græcia*, which had appeared the previous year.

Finally, 'The Treasurer reported, That his Majesty had appointed Mr Thomas Davies [a well-known bookseller based at 8 Russell Street, Covent Garden] as Bookseller to the Royal Academy & Dr Molins [that is, Peter Molini, who was based in London] foreign Bookseller to the Royal Academy.'

One might have hoped that there might have been some reference in the minutes of the Council meeting to a mysterious rumour that was circulating to the effect that Reynolds was threatening – had, indeed, threatened – to resign. In a letter that the actor David Garrick received from Joshua Sharpe, a lawyer in the Inner Temple, he was told that

> The President Reynolds … has desired to resign; that the King sent to him and insisted on his continuing; Reynolds returned that he owed his Majesty the duty of a subject, but no more; and that as his Majesty had never sat to him, as he had to many others, he desired to adhere to his resolution. The King then said he *would* sit to him: since that, another of the artists has applied for the like honour.

This may just have been ill-informed gossip. But we know from other sources that Reynolds was less enthusiastic than some of the other Academicians on the project of the Royal Academy. He may have had his ear bent by some of the aggrieved members of the Society of Artists. He may have begun to worry how much work his duties as President required and started to resent the fact that the other officers were being paid, while he was not. He is known to have been irritated by the fact that he had not been asked to paint a portrait of the King. So, there may have been truth in the rumour.

The only corroboration is that Reynolds had been to see the King for dinner two days earlier and had had a meeting with Chambers the following day. At the Council meeting, he reported that the King had now approved the additional Laws agreed at the January meeting of the General Assembly, while the Secretary reported that the letters he had been instructed to write had now been written. Mr Addison, who was based in Long Acre and was known for his lay figures (he had also recently made a wooden leg for Josiah Wedgwood), had been asked to attend this meeting and 'made proposals for the making a Layman to have the Motions of the Human Body'. This was expected to cost up to £100.0.0, an enormous sum, so, perhaps

not surprisingly, Addison was asked to 'deliver his Proposals in writing and sign a written agreement for the same'.

Most of the meeting was devoted to the procedure for elections. It was 'Resolved, That the General Annual Election shall be by Ballot of the Members present, and shall be decided by the Majority' and 'That at the Election of Academicians the absent Members shall be permitted to give their Suffrages sealed up and inclosed in a Letter signed with his own hand and directed to the President'. This was significant. Postal votes are not allowed nowadays, because the process of election is expected to rely on discussion and debate within the General Assembly, but it may reasonably have been felt that this would debar those who were, for one reason or other, unable to attend.

The Keeper then 'presented several Drawings done from the plaister Casts in the Royal Academy' in order to admit more students.

Pierre-Etienne Falconet (aged 27; plate 40), whose father was sculptor to Catherine the Great, was sent to learn to paint under the tutelage of Joshua Reynolds. Apparently 'on his first arrival in London, he drew the profile portraits of twelve of the principal English artists, in black lead, and a slight tint of colour on the cheeks and draperies'.

Charles Reuben Riley (or Ryley) (aged 17), the son of a trooper in the Horse Guards, had first studied to be an engraver, and then switched to painting under John Hamilton Mortimer.

Matthew Liart (aged 33) was, according to J. T. Smith, the son of a sausage maker. He had been apprenticed to Simon Ravenet, and had previously exhibited fine engravings after Old Master paintings at the Society of Artists.

William Parry (aged 25) was the son of a well-known Welsh harpist. He had come to London in order to study at William Shipley's draw-

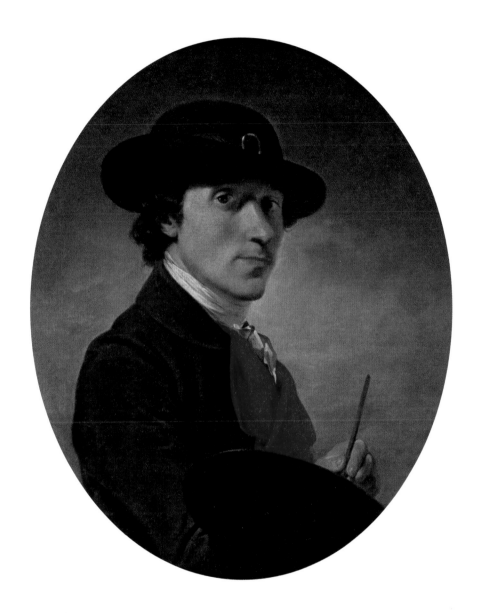

40. Pierre-Etienne Falconet, *Self-portrait*, 1770

ing school, and won prizes for his drawing after the antique. In 1766 he became a student of Joshua Reynolds.

William Lawranson (aged 26) had won a series of premiums for the drawings he had exhibited at the Society of Artists, was known for his 'fancy pictures', and must already have been developing antiquarian tastes since he was elected a Fellow of the Society of Antiquaries two years later.

William Hamilton (aged 17) was the son of Robert Adam's clerk of works. Helped by Adam, he went to study in Italy under the painter Antonio Zucchi. While there, like so many others, he is said to have fallen for the charms of Angelica Kauffman.

John Milbourn (age unknown) was a student of Francis Cotes. He worked for John Russell, the pastellist, and had been awarded premiums by the Society of Arts in 1763, 1764 and 1765.

Benjamin Vandergucht (aged 16) was said to be the thirty-second child of the astonishingly fecund engraver Gerard Vandergucht. Later in his career, Benjamin turned from printmaking to being a full-time dealer.

Finally, the Secretary was asked to 'write a Letter of thanks to Mr Brisbane for the Present made to the Academy of his Book of Anatomy'. This was a copy of John Brisbane's *Anatomy of Painting: with an Introduction Giving a Short View of Picturesque Anatomy*, which had just been published and which the author specifically 'treated with a view to the arts of Design'. Perhaps hedging his bets, he gave a copy to the Society of Artists as well.

Tuesday
28 February 1769

Joshua Reynolds produced what he had written by way of a preface to the catalogue for the first Annual Exhibition. His tone was mildly apologetic:

> As the present Exhibition is a part of the Institution of an
> Academy supported by Royal Munificence, the Public

may naturally expect the liberty of being admitted without any Expence.

The Academicians therefore think it necessary to declare that this was very much their desire but that they have not been able to suggest any other means than that of receiving Money for Admittance to prevent the Room from being filled by improper Persons, to the intire exclusion of those for whom the Exhibition is apparently intended.

Arrangements were made for the Annual Exhibition to be advertised in the relevant newspapers. Council turned its attention to rules for the library, the fact that it was to be open on Wednesdays only, from nine o'clock in the morning to three o'clock in the afternoon, who was to invigilate, and a requirement that 'No Person shall be permitted to trace or calk any Pictures, Drawings or Prints, nor shall they be permitted to use any Ink Black or Red-Chalks, but Black-Lead Pencils only'.

More students were admitted.

Thomas Jones (aged 27), slightly surprisingly, was among them, despite the fact that he had been closely involved with the group of younger artists who had objected to the way that the Society of Artists was being run. He was certainly well qualified, having grown up at Pencerrig, his family's estate in Radnorshire, then trained for the ministry at Jesus College, Oxford. Following the death of his uncle, who had wanted him to go into the Church and had paid for his studies at Oxford, he was free to follow his 'natural bias' for landscape painting and was sent to study first at William Shipley's drawing school, then at the Duke of Richmond's drawing school, before becoming one of four apprentices to his fellow Welshman Richard Wilson.

John Feary (age unknown) won a premium from the Society of Arts for work by artists under the age of twenty-one in 1766 and was apparently spotted by Joseph Nollekens at one of Reynolds's

lectures together with 'all the other deformed students in the Academy', a disobliging reference to the fact that a number of the students had some form of physical handicap, including, for example, John Flaxman, who was hunchbacked, and Edward Edwards and Charles Ryley, who were both slightly crippled.

James Durno (age unknown), the son of a Scotsman who ran a brewery in Kensington, had won premiums from the Society of Arts in 1762 and 1765 for his drawings, and was later awarded 100 guineas for a painting.

Philip Reinagle (aged 20), born in Edinburgh the son of a former trumpeter in the Hungarian army, had been sent by sea to London to become an apprentice to Allan Ramsay, the best-known Scottish painter.

Professor William Hunter came to a meeting to discuss the lectures that he was planning to give the following October. He said that he would also like to give lectures on the musculature of the body, but, to do so, would need a cadaver, which he could obtain only with the permission of the Sheriff. He suggested that Council would be likely to get this permission.

Arrangements were discussed for drawing from the female model, who was to come three days a fortnight. It was agreed that 'no Student under the Age of Twenty' should be admitted 'to draw after the Female Model (unless he be a married Man)'.

It was then ordered that an 'Abstract of the Institution, with the Rules and Orders be printed' by William Bunce, who had been appointed as the Royal Academy's printer in December. This was an important document, of which only one copy survives in the Royal Academy's archive. It reproduced the Instrument of Foundation, but in conjunction with the many bye-laws which had been discussed and agreed since December.

Finally, a further group of students was admitted.

Joseph Farington (aged 21; plate 41), the son of the Rector of Warrington, was sent to train as an artist under Richard Wilson, and won premiums from the Society of Arts for his landscape drawings. His diaries were to become a key source for the early history of the Royal Academy.

James Nixon (age unknown) was the son of a wealthy Irish merchant and a close friend of Joseph Farington, drawing a portrait of him in watercolours, which he is thought to have exhibited at the Society of Artists in 1765 and much later was to present to Farington as a record of their friendship. When Farington showed it to his friends they 'thought it a picture painted with breadth – much upon Sir Joshua's principle – & well coloured'.

John Downman (aged 18) came from Ruabon in North Wales, and had studied in Liverpool before being apprenticed to Benjamin West.

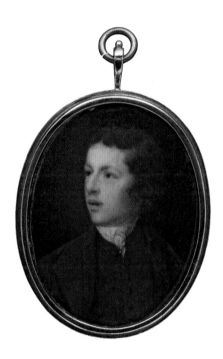

41. James Nixon, *Joseph Farington*, 1765

On a day when he had four sittings for portraits, at 11 o'clock, 12 noon, 2 o'clock and 3 o'clock, Reynolds sat down to write a long letter to Sir William Hamilton, the great collector and British envoy in Naples, with news of what had been happening in London, including an account of the foundation of the Royal Academy:

> I have the pleasure to acquaint you that the Arts flourish here with great vigour, we have as good Artists in every branch of the Art as any other nation can boast. And the King has very seriously taken them under his protection; he has establishd an Academy which opend the first of January.

He told him how the Academy was currently using Lambe's Auction Rooms as its premises, but that there were plans to erect a new building. He then gave Hamilton quite a detailed description of how the Academy operated, based on the Laws, now newly printed, which he promised to send him. A very faint note of resentment can be discerned when he describes how the office of President was the only one with no stipend attached, while Chambers was being paid £60 a year and each of the Professors £30. Reynolds was particularly pleased that the Academy was in the process of assembling a good collection of books, not least owing to the generosity of the King, who allowed the Academy to draw freely on funds from the privy purse:

> Eight other members are appointed to form the laws, and it is this body which is calld the Councill who govern the Academy, the King interests himself very much in our success he has given an unlimited power to the Tresurer to draw on his Privy Purse for whatever mony shall be wanted for the Academy we have already expended some hundred pounds in purchasing books relating to the Arts.

At more or less the same time (the letter is not dated), Reynolds wrote a long and helpful letter to James Barry (plate 42), a young Irish painter then based in Rome, giving him advice on how not to succumb to the temptation of making copies of Old Master

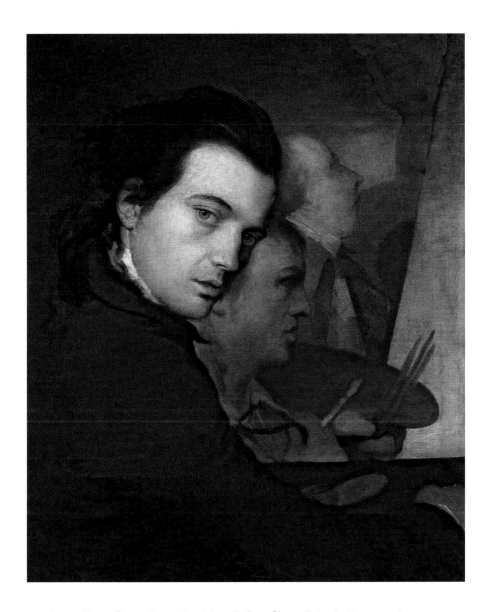

42. James Barry, *James Barry, Dominique Lefevre, James Paine the Younger*, 1767

paintings just for the sake of earning money and, instead, to concentrate all his attention on studying works in the Vatican Museums and especially the Sistine Chapel, since 'it is *there* only that you can form an idea of the dignity of the art, as it is there only that you can see the works of Michael Angelo and Raffael'.

Reynolds ended the letter by telling Barry about the Royal Academy:

> I suppose you have heard of the establishment of a royal
> academy here, the first opportunity I have I will send you
> the discourse I delivered at its opening, which was the first
> of January.

In particular, since he thought that Barry was likely to join the Academy in due course, he encouraged him to find out as much as possible about the operation of the various academies in Rome:

> As I hope you will hereafter be one of our body, I wish you
> would, as opportunity offers, make memorandums of the
> regulations of the academies that you may visit in your travels,
> to be engrafted on our own, if they should be found to be useful.

Barry did already know about the establishment of the Royal Academy because in a long, undated letter (it presumably comes from roughly this period) to his mentor and patron, Edmund Burke, he had told him that he was not 'over and above pleased with the founding of an academy in England', unless it was to contain 'a fine collection of gessos or casts of the antique, and the medals, sulphurs, books, &c. they intend accumulating, will be an acquisition of the greatest value to the public'.

This was to be a key issue in the future history of the Academy: was it to contain a collection of works of art as Barry certainly and Reynolds possibly would have liked? In practice, artists were happy to have works from which to copy and to study the antique; but they stopped short of wanting to ally themselves too closely to the more scholarly aspects of establishing a collection. As far as Barry was

concerned, 'I should die of chagrin and melancholy in any place where there is not this, as my thoughts day and night run on nothing else but the antique.'

At this early stage of his career, Barry was pleased that 'Mr Reynolds is at the head of this academy', because 'whilst it is in such hands as his, we shall have nothing to fear from those shallows and quicksands upon which the Italian and French academies have lost themselves'. It was only much later, when he had been elected an Academician and the Professor of Painting that his views were to come so radically into conflict with those of the Academy that he was expelled.

Tuesday
4 April 1769

At a meeting of Council, the Treasurer was able to report 'that the several Laws which were confirmed at the General Assembly of the Academicians held on the 25th Day of March, had been presented to His Majesty, for His Majestys Approbation, who was most graciously pleased to signifie his Approbation by his Sign Manual'. It was reported that John Malin, the Porter, had died. Council agreed to cover his funeral expenses. More students were admitted.

James Tassie (aged 34), a Scot born in Pollokshaws outside Glasgow, was initially trained as a mason by his father. He recalled later in life how he was 'first brought up in work-man-ship of Sculpture the size of life'. However, he soon moved to the Academy in Glasgow, which had been established in 1754 by two printers, Robert and Andrew Foulis. They are likely to have inspired his interest in the antique. In 1763 he moved to Dublin, where he became friends with Dr Henry Quin, a collector of classical cameos, who encouraged him to devise a technique to reproduce them in glass. This enabled him to move to London where he lodged in Great Newport Street. More than most of the early students, he did not need the teaching offered by the Royal Academy Schools, but probably appreciated the intellectual milieu there and the contact with like-minded pupils.

Thomas Clark (age unknown) was also from Ireland and had been trained at the Dublin Drawing School. He sent three portraits for exhibition at the Dublin Society of Artists in March 1767, and moved to London soon after. He was to become a pupil of Reynolds, but was said by James Northcote to have been extremely difficult; his pupillage did not last long.

John Kitchingman (aged 29) had been trained at William Shipley's drawing school, won premiums at the Society of Arts every year from 1762 to 1766, and regularly exhibited miniatures at the Free Society. He was said to be 'fond of naval pursuits' and was later to win the Duke of Cumberland's Cup in the annual sailing competition on the Thames.

Thursday *13 April 1769*	According to a newspaper advertisement placed by Francis Milner Newton, 'Thursday the 13th Day of April, or before Six o'Clock in the Evening on Friday' was when 'the ARTISTS who intend to exhibit with the ACADEMICIANS' were to deliver work to be considered for the Academy's first Annual Exhibition.
Saturday *15 April 1769*	Council met to inspect the works submitted to the first Annual Exhibition. They resolved 'That the Academicians & Exhibitors be inserted in the Catalogue by their Christian Names & that Mr be left out.'
Thursday *20 April 1769*	Council met again to look at, and approve, the arrangements for the first Annual Exhibition, agreeing to 'the present Arrangement, of the Pictures &c in the Exhibition'. It was agreed that Professor William Hunter should have the right to visit the exhibition 'whenever he pleases' and 'That Catalogues be sent to the great Officers of State & one to the Earl of Bessborough', presumably in acknowledgement of his gift of two drawings.

Saturday *22 April 1769*	Reynolds attended a levee at St James's Palace and received a knight-hood for the work he had done on behalf of the Royal Academy. Later the same day, his friend Samuel Johnson, who had touched no alcohol for a decade, drinking only tea and lemonade, broke his fast and 'drank a glass of wine to the health of Sir Joshua Reynolds on the evening of the day he was knighted'.
Tuesday *25 April 1769*	The King visited the Annual Exhibition with the Duke of Glouces-ter and two visiting German princes. According to the *London Gazette*, 'they expressed themselves highly satisfied'.
Wednesday *26 April 1769*	The Royal Academy's first Annual Exhibition opened in Lambe's Auction Rooms in Pall Mall. Admission cost a shilling, but the catalogue was free, as had been the policy of the exhibitions organised by the Society of Artists in Spring Gardens.

The catalogue, printed by William Bunce, included 136 works, listed by artist alphabetically. A quotation from Vergil appeared on the cover, 'Major rerum mihi nascitur ordo' ('a mightier order of things is born'), which represented the artists' ambitions for the exhibition.

The first artist listed was John Bacon, who had been born in Dorset and apprenticed to Nicholas Crispe, owner of a porcelain factory in Vauxhall. Bacon's address was given as 'George-yard, near Soho-square, in Oxford-road' and he exhibited two works: a 'PORTRAIT of his MAJESTY, a medalion' and 'Bacchanalians (a model)'. John Baker RA from 'Denmark-street, Soho' showed 'A piece of flowers' and 'Its companion'. George Barret RA showed 'A view in Penton Lynn, on the river Liddle, running through Canonby, in the county of Dumfries, three miles south-east of the first Turnpike on the new Road from Carlisle, through the Duke of Buccleugh's estate, to Edinburgh' and 'Part of Melrose Abbey on the river Tweed, by the moon-light, belonging to his Grace the Duke of

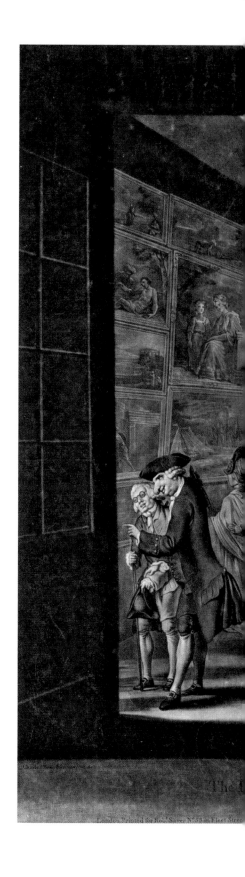

43. Richard Earlom after Michel Vincent 'Charles' Brandoin,
The Exhibition at the Royal Academy in Pall Mall, 1771, 1772

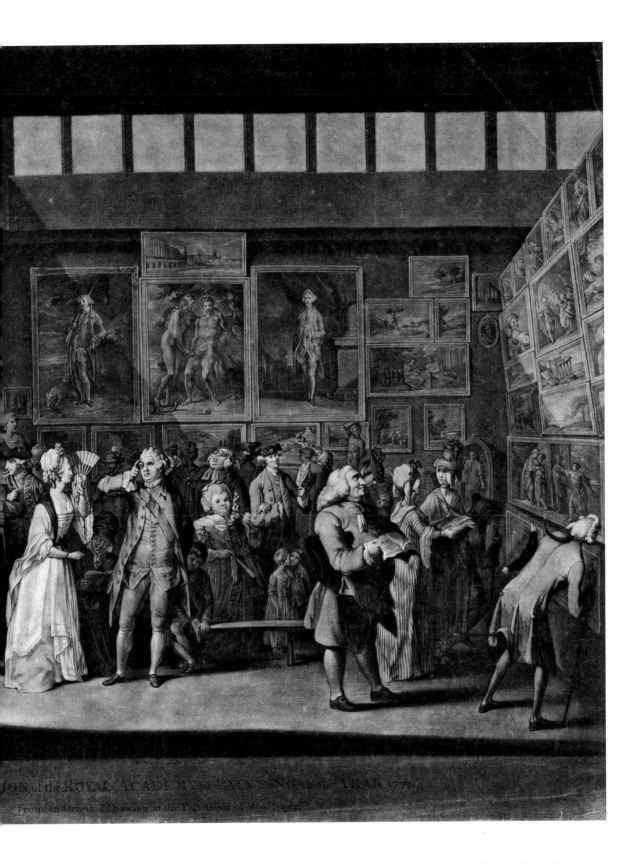

ION of the ROYAL ACADEMY of PAINTING &c. in the YEAR 1771

From an Original Drawing in the Possession of Rob. Sayer

Published as the Act directs April 4

Buccleugh'. The variability in the detail of the titles given to the pictures is intriguing, ranging from unspecified floral pictures to very detailed topographical views.

Carlini showed 'A model of an equestrian statue of the King' (plate 44), a wonderfully grand maquette of their patron riding a horse and dressed as a Roman senator. Chambers described himself as 'Comptroller General of the works to the King, architect to the Queen, and to her Royal Highness the Princess Dowager of Wales, and Treasurer of the Royal Academy, Berner's-street' and showed, among other work, the 'Elevation and plan of a hunting casine, belonging to the Right Honourable the Earl of Charlemont in Ireland', in other words, a drawing of the very sophisticated small Casino that Chambers had designed at Marino, near Dublin, for the 1st Earl of Charlemont, whom Chambers had got to know in Italy. Francis Cotes showed a number of portraits, including a half-length whose sitter Horace Walpole identified as Mrs Bouverie in his copy of the catalogue, and a double portrait of William Earle Welby and his wife Penelope playing chess. 'A portrait in crayons of his Royal Highness the Duke of GLOUCESTER' by Cotes was said by Walpole to be 'Exceedingly like' and the same artist's 'A young lady ditto in the character of Hebe' he thought 'very pretty'. There was certainly no danger of missing the royal connection.

Thomas Gainsborough, listed as residing in Bath, exhibited 'A portrait of a lady', which was the fine, full-length portrait of Isabella, Viscountess Molyneux (National Museums and Galleries on Merseyside), based on Van Dyck. The work caught the eye of the critics as it was claimed to be one of the paintings 'that have this season attracted the attention of the Connoisseurs', although Walpole thought that, while it was 'very like', it was 'ungracefull'. Gainsborough also showed 'A large landscape' and 'A boy's head'.

Francis Hayman, now well past his prime and taking a back seat in the affairs of the Academy, exhibited two scenes from Don Quixote, one of his favourite sources of subject-matter. Elias

44. Agostino Carlini, *Model for an Equestrian Statue of King George III*, 1769

Martin, described by Horace Walpole as 'a Swede, excellent for character & charicatura', showed 'A view of Westminster-Bridge, with the King of Denmark's procession by water, taken from Mr Searle's Timber-yard'. Walpole dismissed this as 'most tawdry & unnatural'.

Sir Joshua Reynolds showed four works, all listed as if they were subject pictures, although they were all really portraits masquerading as subject pictures: 'A portrait of a lady and her son, whole lengths, in the character of Diana disarming love', which was a picture of the Duchess of Manchester and her son (Wimpole Hall), the duchess in the guise of the goddess Diana plucking the wings from a rather mawkish depiction of her son, Lord Mandeville, a pose that Horace Walpole wrote off in his marginal notes as 'bad attitude'; 'A ditto of a lady in the character of Juno, receiving the cestus from Venus', which Walpole thought 'very bad'; 'Portraits of two ladies, half lengths. Et in Arcadia ego', which was *Mrs Crewe and Mrs Bouverie* (Private collection), two of the most famous beauties of the day, 'moralizing', according to Walpole, 'on the tomb of Lady Coventry'; and *Hope Nursing Love* (Bowood Collection), a picture based, as Walpole recognised, rather too obviously on the work of Correggio. Its sitter, a young actress named Miss Morris, had made her stage debut on 28 November 1768, sat to Reynolds in January 1769, and died on 3 May, just over a week after the Annual Exhibition opened.

There was also more adventurous, new work by younger artists, including, for example, Benjamin West's *The Departure of Regulus from Rome* (plate 45), which the King had particularly encouraged him to exhibit and which caused Zuccarelli to declare: 'A figo for Poussin, West has already beaten him out of the field.' West's work attracted the attention of a correspondent in *The Public Advertiser*, who wrote that nothing 'can exceed our Charming History Painter, Mr West, in the Correctness of his Composition, the Harmony of his Stile, or the Delicacy of his Colouring' and concluded that 'the

45. Benjamin West, *The Departure of Regulus from Rome*, 1769

Superiority of History-Painting over Works of every kind is now universally acknowledged'. Horace Walpole was less impressed, annotating his catalogue with the comment 'good drawing & composition but hard & heavy'.

Although, as we have seen, one of the purposes of the Royal Academy was to improve the status of history painting, the actual range of works it exhibited was then, as it has been ever since, a deliberate mixture. The majority of exhibitors were Academicians, but by no means all. The non-Academicians included John Bacon, Samuel Cotes (Francis Cotes's older brother, who had started life as an apothecary but then turned to painting miniatures), Edmund Garvey from Bath, and S. H. Grimm, whose address is listed (no doubt provoking a raised eyebrow) as 'At Mrs Sledges, Henrietta-street, Covent-garden'. Thus, history paintings were combined with traditional work by more established artists; subject painting alongside portraiture; architectural drawings mixed in with paintings. There was a significant amount of topographical painting, including 'A view from the gun-wharf at Portsmouth' by Dominic Serres and, in the category listed as HONORARY (presumably the amateurs) there were 'The falls of Niagara, a drawing, by Capt. Hamilton, of the 15th Regiment' and 'A view of Cliefden from the Meadows, by Theodosius Forrest, Esq.', the latter the lawyer who had given advice to the Directors of the Society of Artists the previous summer.

From the beginning, eclecticism and breadth of representation were the order of the day, in order to give the public a reasonable conspectus of current work; and the Annual Exhibition was seen, then as now, by 'a very crowded and brilliant route of persons of the first position'.

That evening, the new Academicians could look back on an extremely busy, but remarkable, three months, in which the essential character of the Royal Academy had been formed through a process of hard work, debate and discussion. The fledgling institution enjoyed the support of the King, who had agreed to underwrite

its losses. In Sir Joshua Reynolds, it had a President who was held in high esteem and who, in his Discourses, was able to provide a great fund of practical advice to the Academicians, the students and the wider public, such that the Discourses became known as a statement of academic practice throughout Europe. In William Chambers, it had a Treasurer who was able to look after its finances scrupulously, if occasionally somewhat opaquely, as emerged after his death. Like Sir Joshua Reynolds, Chambers was a leader in his profession, capable of writing highly intelligently about the practice of architecture, and who, in designing Somerset House, was to provide the Royal Academy with its future home. Whatever Francis Milner Newton's defects may have been as a person (he was regarded by his contemporaries as mean-spirited and overly legalistic), he was a conscientious and scrupulous Secretary. And George Michael Moser was an able and experienced Keeper, who was well equipped to establish an appropriate system of training for young artists.

However much the Royal Academy was to change and evolve, its essential character had been established in those first three months, during meetings with the King, debates at the General Assembly, the long and arduous discussions at the regular meetings of Council, and presumably over a drink or two at St Alban's Tavern.

5 *The Next Two Years*

Thursday
27 April 1769

Sir Joshua Reynolds, or 'Sir Josh-u-ay' as he was nicknamed by contemporaries, presumably in mockery of his Devon accent, held a small private dinner party as 'a Treat occasioned by his being Knighted'. He didn't bother to invite any artists, only his literary friends, the majority of whom were members of the Literary Club, including Samuel Johnson; Edmund Burke; Robert Chambers (no relation of William), who was Vinerian Professor of Law at Oxford; Christopher Nugent, an Irish doctor; Bennet Langton, tall, thin, charming and erudite; William Jones, the great orientalist; Thomas Leland, who had published *The History of Philip, King of Macedon* in 1758; John Hawkesworth, who was occupied in compiling the official account of Captain Cook's voyages; and Thomas Percy, chaplain and secretary to the Duke of Northumberland. The guest list demonstrates Reynolds's preference for men of letters over the hurly-burly of the artistic community.

Wednesday
3 May 1769

In an article in the *Middlesex Journal*, mouthpiece of the Wilkesite opposition to the Crown, the King was denounced for having backed the establishment of the Royal Academy, rather than maintaining his support for the Society of Artists:

You disdain, then, sir, to mingle your royal favour with the
vulgar, the honest, ardent wishes of the people, in support of
the society of artists of Great Britain; and therefore instituted
the royal academy, so that the plumes of prerogative might
wave in triumph over the cap of liberty.

This is an indication of how the Royal Academy was perceived by
those not associated with it. Hardly surprisingly, royal patronage
for the group of artists who had broken away from the Society of
Artists had created a sense of grievance and a feeling that the King
preferred to support a small and élite group of artists under his
direct control, rather than the much more democratic, if fractious,
Society of Artists.

Sunday
4 June 1769

The poet laureate, William Whitehead, composed an 'ODE for His
MAJESTY'S Birth-Day', as he was required to do twice a year, once for
the new year and once for the King's birthday. This time he celebrated
the opening of the Royal Academy:

Patron of Arts! at length by Thee
Their Home is fix'd: Thy kind Decree
Has plac'd their Empire here.
No more, unheeded, shall they waste
Their Treasures on the fickle Taste
Of each fantastic Year.
Judgement shall frame each chaste Design,
Nor e'er from Truth's unerring Line
The sportive Artist roam.

This was not great poetry, but when performed in the Great
Council Chamber of St James's Palace, it reflected the King's pride in
having successfully helped to establish an academy. Meanwhile, the
artists celebrated their royal patron's birthday with a grand party and
by decking out their premises with lamps and transparent paintings,
which were mainly by Cipriani, with help from Benjamin West and
Nathaniel Dance, who painted the side panels. Horace Walpole kept
the press cutting that described its iconography:

In the center Compartment appeared a graceful female Figure seated, representing Painting, surrounded with Genii, some of which guided her Pencil, whilst others dictated Subjects to her; at her Feet were various Youths employed in the study of the Art, and over her Head hovered a celestial Form, representing Royal Munificence, attended by several other Figures supporting a Cornucopia, filled with Honours and Rewards.

To the left was an additional panel representing Sculpture, and to the right, one representing Architecture. Above the central panel was an inscription which read: Royal Academy of Arts, Instituted MDCCLXVIII.

Thursday *15 June 1769*	Council decided to commission an engraving of the Diploma that was to be awarded to each Academician and whose wording had been devised by Chambers and the King, as well as a Gold Medal, which was to be awarded to the best of the students annually. They invited suggestions from the Visitors '& that the Keeper be likewise desired to give a design'.
Friday *30 June 1769*	Moser's design for the Diploma (plate 46) was selected, with a request for some small alterations.
Monday *10 July 1769*	Council must have changed its mind and adopted Cipriani's design (plate 47) instead, again with a great number of suggested alterations. Its members were clearly passionately interested in the Diploma's iconographic significance, requiring, for example, that 'the Boys at the feet of the Arts' be left out and 'That the Spear of Brittania [*sic*] be continued to the edge of the Medallion'.
Friday *13 October 1769*	Council chose Cipriani's designs for the gold and silver medals, following Edward Penny's brief for their iconography. The motto 'haud facilem esse viam voluit' ('He does not want the path to be easy') was agreed, in recognition of the belief that the path to art lay

46. George Michael Moser, *Design for the Headpiece of the Royal Academy Diploma*, 1769

47. Giovanni Battista Cipriani, *Design for the Headpiece of the Royal Academy Diploma*, 1769

through hard work. Cipriani was voted a silver cup, and it was 'Resolved that Mr Moser do make a Model after Mr Cipriani's design for the Gold Medal, & likewise another for the Silver Medal, in order for the Engraver to work after, and the size be according to the Value already fixt.'

Monday
27 November 1769

Council was informed of the King's intention to nominate Zoffany as an Academician without going through an election, to which Zoffany had refused to submit. He had told Joshua Kirby that he was resigning from the Society of Artists because he was going abroad, but, as the *Middlesex Journal* reported contemptuously, 'Mr Zoffani's journey into *foreign parts* was from *Lincoln's Inn Fields* to *Pall Mall* ... What could we expect from this *great traveller* but *lies?*'

Monday
11 December 1769

On the near-anniversary of the signing of the Instrument of Foundation, a General Assembly was held. Reynolds had to be re-elected President, which was probably just a formality, although it was one of the principles of democratic accountability that the holder of that office had to stand for re-election every year (and still does). Zoffany's appointment as an Academician was confirmed, and so, too, was the appointment of William Hoare, who, like Zoffany, had been listed as a foundation member but only accepted following personal nomination by the King. Prizes were given out to the best of the students, including Gold Medals to James Gandon 'for the best design in architecture' and to John Bacon, a rising star, 'for the best model of a bas-relief'.

The General Assembly then discussed a perplexing issue. Once the Academy had been founded, it had become obvious that there were not nearly enough places for the number of artists who might want, and would be eligible, to join as Royal Academicians. Moreover, some artists were regarded as worthy, but not quite good enough. Council came up with a compromise, which was to enlarge the category of Associate members, first established in January to

accommodate engravers. Associate members were now to be regarded as apprentices to the full order:

> There shall be a new order, or rank of members, to be called
> associates of the Royal Academy.
>
> They shall be elected from amongst the exhibitors, and be
> entitled to every advantage enjoyed by the Royal Academicians,
> excepting that of having a voice in the deliberations, or any
> share in the government of the Academy; neither shall they have
> admittance to the library but on public days, or the liberty of
> introducing strangers to the lectures.

Reynolds then gave his second Discourse, this time to a much larger audience, including many of the 77 students who had been admitted to the Schools during the course of the Royal Academy's first year.

Reynolds congratulated the students who had been awarded medals and, at the same time, reminded them that their studies were only just beginning. He spoke more freely and with the confidence of having steered the Academy through the first year of its history. He addressed his remarks particularly to those Students 'who have been this day rewarded for their happy passage through the first period' in the Theory of Art, which he regarded as a facility in drawing, 'a tolerable readiness in the management of colours, and an acquaintance with the most simple and obvious rules of composition'. He light-heartedly indulged in a sea-faring analogy:

> A Student unacquainted with the attempts of former adventurers,
> is always apt to over-rate his own abilities; to mistake the most
> trifling excursions for discoveries of moment, and every coast new
> to him, for a new-found country. If by chance he passes beyond his
> usual limits, he congratulates his own arrival at those regions
> which they who have steered a better course have long left behind.

As in his letter to James Barry earlier in the year, Reynolds suggests that the students should not waste time in the 'drudgery of copying', and as he had in his first Discourse, he continually

emphasised the need for hard work and diligent study of Old Master paintings, and not dependence on genius alone. His advice is invariably sensible and practical, based on his own experience:

> A facility of drawing, like that of playing upon a musical instrument, cannot be acquired but by an infinite number of acts. I need not, therefore, enforce by many words the necessity of continual application; nor tell you that the porte-crayon ought to be for ever in your hands.

Art was to be regarded as more a matter of intelligent composition, based on historical precedent, than one of originality:

> There is one precept, however, in which I shall only be opposed by the vain, the ignorant, and the idle. I am not afraid that I shall repeat it too often. You must have no dependence on your own genius. If you have great talents, industry will improve them; if you have but moderate abilities, industry will supply their deficiency. Nothing is denied to well directed labour; nothing is to be obtained without it.

This was the lesson that Reynolds wanted students, above all, to absorb: that improvement in art was a matter of hard work and not idle inspiration.

Tuesday
9 January 1770

There were elections to two Honorary Professorships. Reynolds's close friends Samuel Johnson and Oliver Goldsmith were elected to Chairs in 'Antient Literature' and 'Ancient History' respectively, while Richard Dalton, who had done so much to help the Society of Artists as its Treasurer, and who still had the ear of the King on artistic issues, was recruited as 'Antiquary'. Reynolds wrote to Bennet Langton much later concerning the duties required of Professors: 'There is no duty; we desire only the honour of your name, for which you have the entré of the Academy and we give you once a year a very good dinner, I mean that before the Exhibition and you see the Exhibition as often as you please *gratis*.' As Goldsmith commented, being a Professor was 'like ruffles to a man who had no shirt'.

According to Horace Walpole, the second exhibition had 'some very fine things, and fewer bad than in any of the preceding'.

One of the most striking pictures must have been Reynolds's portraits of Colonel Acland and Lord Sydney, known as *The Archers* (Tate), which shows its sitters in magnificently athletic pose, although Walpole, oddly, only said of it, 'Trees very fine'. Alongside this dashing portrait of two youths, he also showed two portraits of young children, which were an attempt to develop a new genre of portraiture, perhaps inspired by his visit to Paris in the autumn of 1768 where he would have seen the work of Greuze. The first was a picture entitled *The Children in the Wood* (untraced). Reynolds was fond of children and, in early March, had begun to employ a 'Beggar child', who came for regular sittings throughout March and, again, in early April. According to James Northcote,

> It happened, once, as it often did, that one of these little sitters fell asleep, and in so beautiful an attitude, that Sir Joshua instantly put away the picture he was at work on and took up a fresh canvas. After sketching the little model as it lay, a change took place in the position; he moved his canvas to make the change greater, and to suit the purpose he had conceived, sketched the child again.

The resulting portrait, which shows a small child fast asleep in a wood in two poses, is, to modern eyes, extremely maudlin, but demonstrates Reynolds's efforts to produce a picture that would live up to the high standards of idealisation that he was advocating in his Discourses. The second was his picture of Miss Sarah Price (Hatfield House), the daughter of Chase Price MP. This was exhibited, without identification of the sitter, as 'Portrait of a Child' and was hugely admired by Horace Walpole, who annotated his catalogue with a note in which he described how 'It is a little Girl with her hands before her amidst sheep & under fine trees. Never was more nature and character than in this incomparable picture, which expresses at once simplicity, propriety, & fear of her cloaths

being dirtied, with all the wise gravity of a poor little Innocent.'

Reynolds was up against Zoffany, who was exhibiting for the first time. His *George III and Queen Charlotte with their Six Eldest Children* (Royal Collection) was an extremely ambitious conversation picture, but Walpole regarded it as 'ridiculous', presumably because of the conceit of them all being in Van Dyck dress. On the other hand, Zoffany also exhibited *David Garrick with Edmund Burton and John Palmer in 'The Alchymist'* (Private collection), described in the exhibition catalogue as 'The last scene of the 2d Act, in the Alchymist' and which, unlike his royal portrait, was hugely admired, thought by Walpole to be 'one of the best pictures ever done by this Genius'. Reynolds immediately bought it for a hundred guineas. Half an hour later the Earl of Carlisle offered to buy it from Reynolds for twenty guineas more. But Reynolds generously waived his interest in the picture, 'resigned his intended purchase to the Lord, and the emolument to his brother artist'. A rather dark picture in a Flemish style, it has clever characterisation and a brilliant depiction of still-life, which Farington regarded as Zoffany's 'Chef D'ouvre of Theatrical representations'.

Francis Cotes exhibited a portrait of the Duke of Cumberland 'in crayons' and further portraits of the Duke of Beaufort, Captain Leister and Mrs Sawbridge, which Walpole annotated as 'Mrs Sawbridge, wife of the Alderman, with a palm branch, & inscription, "Templum felicitatis"'. Nathaniel Hone submitted a picture of two Capuchin friars, listed as 'Two Gentlemen in Masquerade'. Council decided that it was inappropriate that one of them was stirring a bowl of punch with a crucifix, so Hone was required to transform it (at least temporarily) into a ladle.

Among the work of the more obscure exhibitors were pastels exhibited under the name of E. F. Calze. This was the Italian pseudonym of Edward Francis Cunningham, who was the son of a Scottish Jacobite, had been brought up in exile in Bologna and trained to paint in Parma and in the studio of Mengs in Rome. According to

Edward Edwards, he had been 'introduced into England, and much patronized by the second Lord Lyttelton', but his 'profligacy and want of principle obliged him to leave England, but not before he had ill-treated his patron'.

This was the first year that the Royal Academy held an annual dinner, normally, as in 1770, held on St George's Day, to which it invited the great and the good. The guests at the annual dinner included the young Duke of Devonshire, who had recently returned from the Grand Tour and was now devoting himself to drinking and gambling; the Earl of Carlisle, who had also recently returned from the Grand Tour and been painted, dressed in the Order of the Thistle, by Reynolds in his most swagger manner; Lord Grosvenor, who was bringing criminal action against the Duke of Cumberland after he had been discovered *in flagrante delicto* with Lady Grosvenor; Lord Bessborough; David Garrick, one of the subjects of Zoffany's theatrical picture, now acting less, but still managing the Drury Lane Theatre; Horace Walpole, son of a former Prime Minister and an inveterate collector, who had presented the Academy with the second edition of his *Anecdotes of Painting in England*; and Mr Chitqua, who had arrived in London from Canton the previous August and was expert at producing small portrait busts, described by Joseph Bentley as 'small busts in clay, which he colours' and which were much admired by the King.

Although smaller than future dinners and less grand, the 1770 dinner set the tone, with guests who included young, aristocratic collectors and those interested in the arts. Unfortunately, only one menu for an annual dinner survives from this period and it is undated. The first course included fish and sauce, ham, fowls, greens, pigeon pye, roast beef, tongue and turtle, followed by duck, asparagus, geese, lamb and salad. For pudding, they had blancmange and tarts and it was all washed down with claret, madeira, port and sherry in no particular order.

Sunday *24 June 1770*	Reynolds wrote to Sir William Hamilton in Naples to acknowledge receipt of the two casts that Hamilton had had shipped as gifts to the Academy:

> The Bas-relievo of Fiamingo I never saw before it is certainly
> a very fine group and the only thing of the kind that we have
> which makes it a very acceptable present, that, and the Apollo
> are both ordered by his Majesty to be placed in Somerset
> House where our Academy will remove this summer, the Royal
> Apartments are to be converted into a Royal Academy.

Thursday *19 July 1770*	Francis Cotes took a strong poison made of soap, which was supposed to cure his gallstones, but killed him. His pupil John Russell recorded in his diary how 'the sorrowful account of My Late Master Mr Francis Cotes's Death' affected him, 'that a man full of worldly honour and pride with schemes of Business should be cut off without leaving any Marks of knowing the salvation of Jesus'.

Wednesday *25 July 1770*	Mary Moser wrote to Henry Fuseli, a future Professor of Painting and Keeper of the Royal Academy, then living in Rome:

> Sir Joshua a few days ago entertained the Council and visitors
> with calipash and callipee, except poor Cotes, who last week
> fell a sacrifice to the corroding power of soap-lees, which he
> hoped would have cured him of the stone. Many a tear will drop
> on his grave, as he is not more lamented as an artist than a friend
> to the distressed. (Ma poca polvere sono che nulla sente!)

Monday *1 October 1770*	Francis Hayman was appointed Librarian at a salary of fifty pounds a year in order 'that he might enjoy its emoluments, small as they were, in consequence of his bodily infirmities which in the evening of his life pressed heavily upon him'.

Friday *5 October 1770*	Some of the Academicians established an informal dining club called the Friday Nights Club, which met weekly at the Turk's Head Tavern.

Reynolds rose to the rostrum in Lambe's Auction Rooms in Pall Mall to deliver his third Discourse. This was much more ambitious than its two predecessors: nothing less than an attempt to describe the classical idea of beauty and to differentiate between mere imitation and Ideal Beauty. He began by acknowledging that, when an artist starts his training, he needs to concentrate on the 'attainment of mechanical dexterity' and the 'mere imitation of the object before him'. He then spells out his central belief:

> The wish of the genuine painter must be more extensive: instead of endeavouring to amuse mankind with the minute neatness of his imitations, he must endeavor to improve them by the grandeur of his ideas; instead of seeking praise, he must strive for fame, by captivating the imagination.

One wonders, in reading this, if he was possibly influenced by the tremendously favourable response that had been given to Zoffany's theatre painting in the most recent Annual Exhibition. Zoffany was an artist who had brilliant mechanical skills. But did he also have the quality of imagination?

The way to achieve a proper understanding of 'the *great style*' was through study of antique sculpture:

> I know but of one method of shortening the road: this is, by a careful study of the works of the ancient sculptors; who, being indefatigable in the school of nature, have left models of that perfect form behind them.

This was why students were schooled in the study of antique sculpture, so that they would learn lessons of proper symmetry and proportion. Reynolds is always appealing to the lessons of eternity, against the ephemeral seduction of temporary fashion:

> However the mechanic and ornamental arts may sacrifice to fashion, she must be entirely excluded from the Art of Painting; the painter must never mistake this capricious changeling for the genuine offspring of nature; he must divest himself of all prejudices in favour of his age or country.

This was Reynolds's credo as to why the art of painting should be treated as a liberal art. It was a statement of the classical idea of beauty, strongly idealising and clearly based on wide reading of works of aesthetic theory, including Cicero and Plato and, among more modern writers, Francis Bacon. There are echoes in some of the writing of the work of Samuel Johnson and Edmund Burke, which is hardly surprising, since it is likely that this Discourse was derived from Reynolds's discussions with them and he may, indeed, have had help in writing it from Johnson.

Monday
7 January 1771

'Notice is hereby given to the Members and Students, that the Academy is removed to Somerset House, and will open on Monday next 14th Inst. at 5 o'Clo: in the Afternoon.'

Monday
14 January 1771

The Royal Academy moved into its new premises in old Somerset House, a dilapidated royal palace off the south side of the Strand with gardens onto the river (plate 48). This move had been planned for some time, but had been delayed. The premises were a gift from the King and had been converted at a cost of £600 in order to give the Academy proper quarters in which to establish itself. There were rooms for the antique and life class, with the plaster figures 'placed on pedestals that run on castors'. There was a lecture room, equipped with forty chairs, twenty-eight of which were for the Academicians and marked RA and a further twelve behind them for 'Strangers of Distinction', while at the back, there were 'two Benches (with a Back Rail)' for six people each, which were 'for the Associates & marked with the letter A'.

Upstairs, there was an apartment for the Keeper, including a drawing room that had previously been one of the royal bedchambers. Most of the old seventeenth-century furniture had been cleared out, but there was still a long gallery and rooms, including the old audience chamber, 'hung with silk, now in tatters, as were the curtains, gilt leather covers, and painted screens'. Indeed, the

room that was used as a library, with its wonderful folio volumes of prints to act as a source of inspiration for the students, was hung with seventeenth-century tapestries. Stephen Rigaud described how his father, John Francis Rigaud, recalled the rooms in old Somerset House when he first arrived in England from Rome:

> I have heard my Father speak of it as being, on his arrival in England, a very magnificent Building, with spacious and beautiful gardens reaching down to the banks of the river; and where the Schools, Lectures, and Library were held, although the Exhibitions were continued in Pall Mall, for want of a proper exhibition light in the old Palace of Somerset House.

48. Paul Sandby, *View from the Gardens of Somerset House looking East*, *c.* 1760

On the first night, there was a great party, attended by the Duke of Cumberland, to celebrate the fact that the Royal Academy now had a physical setting for its activities, described as 'the most superb of any in the world and the best stocked with casts after the antique'. Sir Joshua Reynolds, as President, took the chair 'to expatiate on the indulgence his Majesty has shown to the arts by conferring on them such an honour in presenting the Academy with apartments in a Royal Palace', before handing over to Thomas Sandby to deliver a lecture on architecture.

6 *Consequences*

It will be obvious to anyone who has studied the early history of the Royal Academy that it was set up to perform a number of different functions, all of which had been fulfilled by other comparable organisations beforehand, but which were combined in the new institution for the first time.

The first and most obvious was a purely social function. The Academy emerged out of the great stew of early eighteenth-century clubs and societies in which artists could meet one another, and sometimes collectors and connoisseurs as well. Artists spend most of their days alone in their studios, with only an apprentice or sitters for company, but in the evening they like to be sociable. In the late seventeenth century, the Virtuosi of St Luke had met at a London tavern to talk about art and they continued to do so in the eighteenth century at the King's Arms in New Bond Street. In the 1720s, there was a group called the Rose and Crown Club (or, more pretentiously, the 'Rosa Cornonians'), which met in a room at the Half Moon Tavern with a punchbowl and 'on the table bottles of wine pipes glasses Tankard etc.' in order to discuss contemporary art. Another, more historically minded group called the Roman Club met at Serle's Coffee House in Lincoln's Inn. Francis Hayman was an early member of the Sublime Society of Beefsteaks, whose meetings were held in a private room behind the stage of the Covent Garden Theatre, where the company would eat beefsteaks, baked potatoes, Spanish onions, beets, chopped shallots and toasted cheese, washed down with punch and

whisky toddy. Joshua Reynolds, so diligent in the day, working to a very strict schedule of sittings, liked nothing better than to go out in the evening to a boozy dinner with friends and, according to Joseph Farington, 'If He went into a Company where there was a Pharo table, or any game of chance, He generally left behind him whatever money He had abt. him.'

Some of the social aspects of the newly established Royal Academy are evident in the group portrait of the Academicians that Zoffany embarked on in 1770 to celebrate the institution's foundation (plate 49). The work was exhibited in the Annual Exhibition of 1772. Everyone is depicted in characteristic pose. Francis Hayman, big and beefy, sits astride a packing case surveying the scene. Joshua Reynolds tilts his elegant silver ear trumpet to catch what Chambers is saying, while Francis Milner Newton leans over Chambers's arm to add some comment. In the middle, William Hunter strokes his chin in puzzlement. Richard Yeo examines the pose of the male model, while Francesco Zuccarelli directs it and George Michael Moser, as Keeper, adjusts the model's arm with a loop of rope attached to the ceiling. In the background, the less prominent Academicians chat and gossip, Paul Sandby leaning on the shoulder of his older brother, Francesco Bartolozzi gripping the arm of his compatriot Agostino Carlini. It is a highly sociable scene, not strictly accurate in the way that it depicts the surroundings, but certainly so in the way that it depicts social relationships. Only Richard Wilson, by now a malcontent, is to be seen lurking in the background.

I don't think one should underestimate this social aspect of the Royal Academy, the tendency for its artists to meet in a tavern after the annual lecture, the pleasure they took in the annual dinner, the way in which friendships that were to last late in life were formed among the students in the Schools. Art movements often arise from within a close circle of competitive allies, who belong to the same generation, live in the same neighbourhood, and share the same beliefs. This was as true for eighteenth-century London as it had been

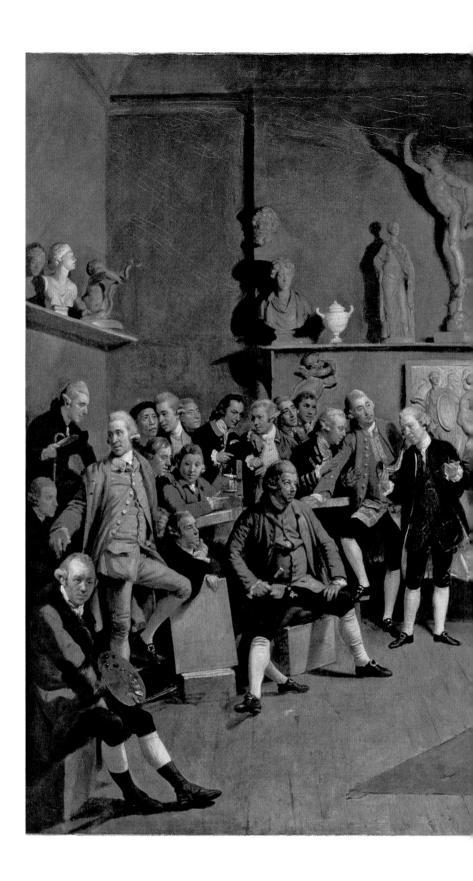

49. Johan Zoffany,
*The Portraits of the
Academicians of the Royal
Academy*, 1770–2

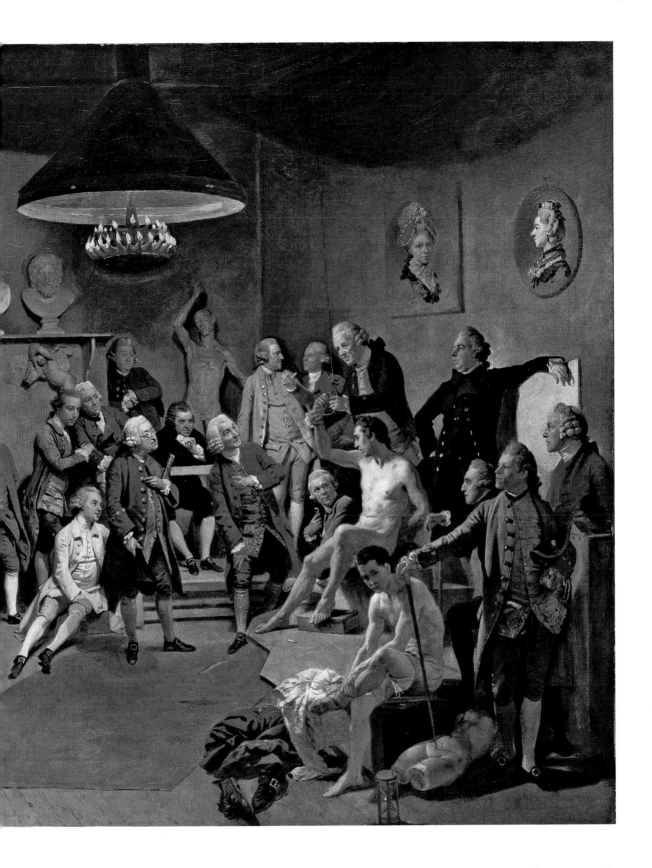

for fifteenth-century Florence and was to be in 1950s New York.

Alongside the Royal Academy's social role stood its status function. The institution helped artists to congregate in order to create a stronger sense of their social and public worth. This was almost certainly the reason why they had never wanted to ally themselves with the Society of Dilettanti, which had made strenuous efforts to establish an academy in 1749. The Academicians did not want to be subordinate to the nobility. Indeed, they did not want to be subordinate to anyone, except the King. The Royal Academicians validated their own sense of self-worth, and something of this swagger is evident in the poses struck by three of Zoffany's sitters. Benjamin West, very tall, turns to address Giovanni Cipriani with an air of affected nonchalance. Nathaniel Hone likewise slightly looks down his nose at the assembled company from behind the model. And Richard Cosway, recently elected, is obviously a fop, with his cane planted squarely on Venus's pudenda.

If one looks back at the art world as it existed in the 1750s, then it is clear that it was a highly competitive milieu, with artists struggling for recognition, hoping for commissions from the nobility, without much opportunity for their work to be seen in the public sphere, except in the Foundling Hospital and the recently established Vauxhall Gardens, where Francis Hayman had been invited to decorate the supper boxes of the Rotunda with history paintings. During the 1760s, artists, particularly those who had been in Rome, were inculcated with the neoclassical ideal that art should have a moral and intellectual content, should be seen by a broad public, and should be able to treat of current historical subject-matter with the same seriousness as Greek and Roman history.

So, one of the ambitions of the Royal Academy was to promote the idea that art was not just a trade, reliant on the development of particular skills through an apprenticeship, but had a set of larger intellectual beliefs, involving reference to the classical tradition and a determination that the practice of art could, and should, have a

serious moral purpose. It should deal not just in the task of depiction, but in characterisation, story-telling, and the world of ideas. These were the lessons that Reynolds emphasised over and over again, that the practice of painting did not just depend on genius and the imagination, but would benefit from long and careful study, from close observation, hard work, and learning the lessons that could be derived from examining Old Master paintings. Art was to be treated as a noble pursuit. The Royal Academy was a way of establishing these ideals.

Then, there was the Exhibition function. The idea of holding an annual exhibition had been at the heart of the Society of Artists and remained at the heart of the Royal Academy. Every year, three Academicians from among the members of Council were paid three guineas a day to be responsible for the selection and hanging of the Annual Exhibition, which continued to be shown in Lambe's Auction Rooms in Pall Mall, even after the majority of the activities of the Royal Academy had moved to old Somerset House in 1771. Every year there was a grand dinner to which the *haut ton* of London society was invited. Presumably sales from the Annual Exhibition contributed to the income of the artists, as they do now.

The fact that the Royal Academy was so much smaller and more highly selective than the Society of Artists greatly reduced the amount of argument about where pictures were to hang. But there were still sensitivities. Thomas Gainsborough, who was still based in Bath, was furious with the way his pictures were hung in the 1772 exhibition and so refused to turn up to meetings of Council when he was co-opted in 1774. Council decided that his name should be struck off the list of Academicians. But the General Assembly refused to accept the vote of Council, reinstated him, and enabled him to exhibit again in 1777, when he showed to universal applause his portraits of the Hon. Mrs Graham and of the musician Carl Friedrich Abel, his close friend, sitting at a writing table.

Art critics nowadays are apt to disparage the idea of the Royal

Academy's annual exhibition, as if it is merely a social event that mixes the good and the not-so-good of contemporary art practice in a way that is regarded as undiscriminating. But it is hard to remember how important it was for eighteenth-century artists to have the opportunity for their work to be seen, judged and assessed by the public, and not just by connoisseurs. The Annual Exhibition was viewed as an opportunity for art to be seen away from Old Master paintings, away from the palaces of the nobility, away from the circumstances of its production, in spaces that allowed comparisons to be made, for work to be assessed, so that the taste of the public could be improved. Until the establishment by artists themselves of annual exhibitions, it had been impossible to view contemporary art except by making arrangements to visit a nobleman's house and paying a handsome tip to his servants. There were dealers in art, but they tended to specialise in Old Master paintings. Before the establishment of the Royal Academy and the other, rival exhibiting societies in the 1760s, there was no sense in which seeing recent work by artists, studying and analysing it, following trends in artistic practice and reading criticism of it in the newspapers was a normal part of the experience of the educated public.

The fourth central aspect of the Royal Academy was its teaching function. Indeed, perhaps its greatest achievement was to provide a proper structure to the teaching of art at a time when becoming an artist had previously consisted merely of an apprenticeship, which depended very much on finding an artist willing to take on an apprentice, or attendance at a drawing school, like the one run by William Shipley. The Royal Academy took its teaching seriously. It required all its Academicians to engage with its students by acting as Visitors. And although there was no fixed curriculum and many of the students were already practising artists, it gave them somewhere to meet, to improve their drawing and to learn some necessary skills, such as a proper understanding of anatomy (plate 50). Most of all, it provided a competitive environment in which to improve these

skills, learning from one another, with the incentive of competing annually for Gold and Silver Medals.

It is almost impossible now to reconstruct how central the Royal Academy Schools were to the practice of art in the late eighteenth century. In the first year alone, besides those artists already mentioned as having been admitted between January and April 1769, John Bacon, the sculptor, was admitted on 24 June 1769 and went on to win the first Gold Medal for a bas-relief of *Aeneas Carrying His Father from Burning Troy*. Thomas Banks, who had already won numerous prizes for the work he had exhibited with the Society of

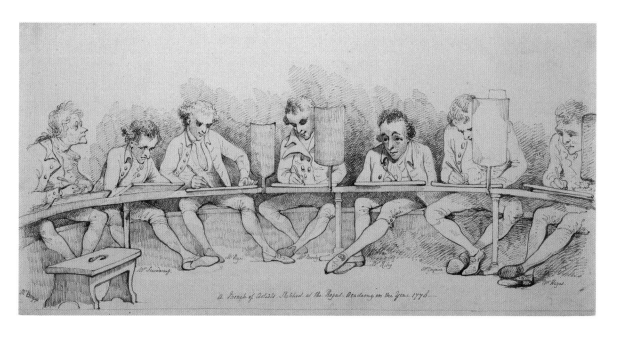

50. Thomas Rowlandson, *A Bench of Artists*, 1776

Artists, joined the Schools on 30 June 1769 and, although not elected an Associate, was awarded the Gold Medal the following year for a bas-relief of *The Rape of Proserpine*. On 7 October 1769, John Flaxman (plate 51) was admitted. It is pretty extraordinary that three of Britain's most important neoclassical sculptors were contemporaries in the Royal Academy Schools, and presumably learned from one another. They are representative of the way in which the Royal Academy Schools acted as an incubator of talent, by enlarging the ambitions of young artists and demonstrating to them the extent to which art demanded content and imagination, as well as the simple exercise of drawing skills.

51. John Flaxman, *Self-portrait at the Age of Twenty-four*, 1779

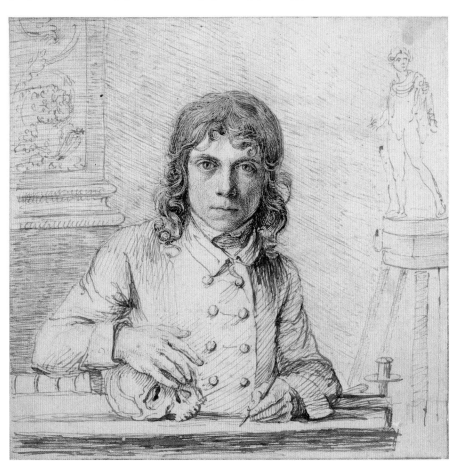

The system of art-school training instituted by Reynolds, Moser and the first generation of Royal Academicians was not, of course, immune from criticism, even in the eighteenth century. Students have always – rightly – criticised the way that they are taught, always seeing the limitations of the existing system. James Barry, who was elected as Professor of Painting in 1781, used his lectures as a means to attack Reynolds, whom he regarded as much too worldly and inclined to trivialise the practice of art. William Blake, who enrolled in the Schools on 8 October 1779, loathed Reynolds and everything he stood for, feeling that he privileged the classical tradition over the imagination. But an art school that trained both Turner and Constable has lessons for the modern system of art teaching.

My own feeling, in looking back at the earliest days of the Royal Academy and its operation, is that it did indeed succeed in what it set out to do: it professionalised the practice of art; it provided a usefully competitive environment in which students of art were able to hone their skills under the benign supervision of the Keeper and the Visitors; it enabled students to obtain a reasonable knowledge of the history of art and of literary subject-matter; above all, it gave them the opportunity to draw from the life day after day, year after year, perfecting their skills of observation and artistic record. Once they had learned the skill of drawing and were judged to have done so by Council and the Visitors, they could develop more general skills of invention, composition and narrative.

These were the ideas and beliefs that were hammered out through discussion and debate in the early days of the Royal Academy: that the practice of art, the establishment of a British School, should be dependent not only on the work of individual artists practising on their own in their studios, in competition with one another and reliant on commissions from private collectors, but also on a community of ideas, the sharing of information, meeting in the tavern after Joshua Reynolds's Discourses and arguing about the ideas that he had proposed.

Finally, by way of conclusion, it is worth considering some of the myths that have accumulated around the foundation of the Royal Academy.

The first is the idea that Samuel Johnson or Edmund Burke were involved. It is true that, in 1760, Samuel Johnson had helped the Society of Artists write to the Society of Arts asking them if it might be possible to use their rooms for an annual exhibition, and also that he drafted the preface to the catalogue in 1762, justifying why visitors were required to pay a shilling. It is also true that both Johnson and Burke were close friends of Joshua Reynolds and fellow members of the Literary Club. They met every Monday evening for supper upstairs at the Turk's Head Tavern, where the artists had also met to establish the Society of Artists. So, there was presumably a considerable exchange of ideas over the port, when they were said to have 'unbosomed their minds freely to each other'.

Reynolds corresponded with Edmund Burke while he was travelling in France in September 1768, writing in admiration of the French attitude to intellectual freedom and describing how 'we have been in company with some of their Witts, and it is amazing how impatient they are to assure you that they think for themselves, that they are not priest ridden in short that they have the honour to be *spriforts* that is in English an Atheist'. In January 1770 Samuel Johnson was made the Academy's Professor of Antient Literature, presumably at the behest of Reynolds, and Reynolds is known to have submitted drafts of the Discourses to Johnson for correction. So, it is certainly true that Reynolds belonged to an intellectual milieu, which was highly stimulating, as well as sociable, and which included many of the most prominent writers and intellectuals in eighteenth-century London.

However, I am not convinced that either Johnson or Burke were involved in the writing of the Laws or contributed much to the actual foundation of the Royal Academy. Reynolds is known to have discussed with them whether or not he should accept the offer of the

presidency. But it needs to be remembered that Reynolds was not a key figure at the time of the foundation of the Royal Academy, but only became so later, through the writing, public delivery and publication of his Discourses.

The second myth is the belief that the Academy's system of governance is in some way related to the American Constitution. There are strong ideas of democracy in the original Laws. From the beginning, there was an awareness that it was in the interests of the Royal Academy to avoid the concentration of too much power in one person. The President was the symbolic head as *primus inter pares*, but he was subject to annual re-election, which meant that, if he ever strayed too far from the interests of his peers, he would not necessarily be re-elected, as happened to Benjamin West in 1806. A certain amount of power was deliberately vested by the King in William Chambers as Treasurer in order to ensure that he could keep an eye on the finances. He was known only half-jokingly by Reynolds as 'the Viceroy'. The Keeper was in charge of the day-to-day management of the Schools and was resident in old Somerset House. And all decisions had to be ratified by a meeting of the so-called General Assembly, which was necessarily democratic in the way that it operated and has normally curbed any enthusiasm for change. This does make the Royal Academy into a social entity that is, in some ways, anti-hierarchical.

However, in the context of the eighteenth-century art world, the Royal Academy represented the art establishment, rather than the young Turks. Its members were those who had broken away from the Society of Artists when the younger artists there decided to object to the continuing dominance of a small coterie of older artists, who did not want to be rotated off the Board of Directors and who were believed to hang their own works in the most prominent positions in the annual exhibition. The Royal Academy was a group of older, more established artists who sought the patronage of the King, many of them already enjoying some form of royal office. The King re-

tained ultimate authority over the operation of the Royal Academy. Indeed, to this day, the reigning sovereign must approve the appointment of both the President and Secretary. The King loathed artists who exhibited any trace of republicanism, including Reynolds. So, it is hard to relate the Academy to the mood that led a group of insurgents to object to the authority of the British monarch in Boston on the other side of the Atlantic eight years later.

In the end, I view the Royal Academy's foundation not as the result of an urge to create an instrument of ideology, but rather as a pragmatic response to the circumstances of the time. It did not emerge from the ideas and beliefs of Reynolds, Burke and Johnson, but from the desire of Chambers, West, Wilton (plate 52), Cotes and Moser to establish a new professional society for 'the arts of design'. The Academy's original Laws met the needs of the moment, and they have had remarkable longevity because they were based on experience, including bad experience.

Looking back from a twenty-first-century standpoint, as the Royal Academy approaches the 250th anniversary of its foundation, I find it fascinating that so many artists' societies and organisations were formed in the two decades between 1750 and 1770. The Society of Arts supported the practice of young artists through the award of prizes. The Society of Artists provided a proper system for the public to view an annual exhibition. The Royal Academy consolidated a small élite within the wider profession.

From the back streets and alleyways of Soho and Covent Garden and as a result of conversations in the coffee houses and taverns around Pall Mall and St Martin's Lane, a small group of artists emerged, upset by the bickering and antagonisms of previous artists' societies, to create an organisation to promote the practice of art and architecture as a high ideal.

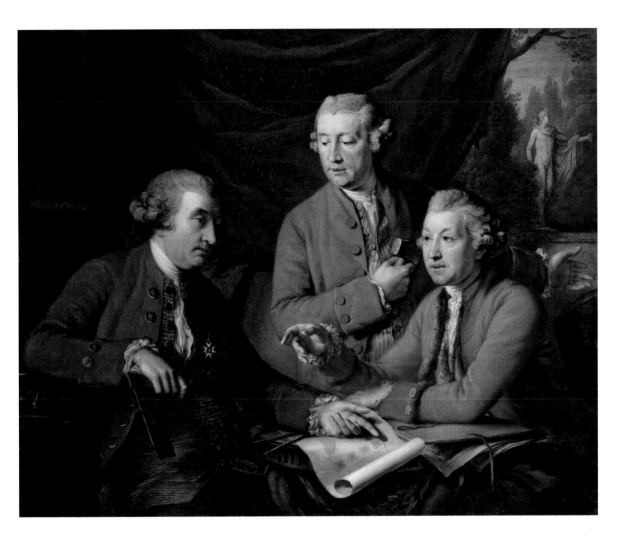

52. John Francis Rigaud, *Sir William Chambers, Joseph Wilton, Sir Joshua Reynolds*, 1782

Epilogue

On 8 December 2011, eighty-four Academicians met in a General Assembly to elect a new President. As they sat together, voting for candidates who each held a slightly different set of views concerning the relative priorities of the Royal Academy, the atmosphere was not unlike that of a bear-pit. It was a good moment to reflect on the extent to which the Royal Academy has, or has not, adapted to changed circumstances.

Many of its characteristics are recognisably of the eighteenth century. Its symbolic head is still the President, whose role is, as it was for Reynolds, to give the institution a sense of leadership, to act as its figurehead, and to keep Council and the General Assembly, when necessary, under control. There is still a Treasurer, who, in exactly the same way as Chambers did, must introduce some semblance of financial order to a body of people who are temperamentally inclined to resist, if not resent, this. For the first time ever, there is a female Keeper, but her role is not so very different from that of George Michael Moser, in that she is required to oversee the work of the students, to ensure that only the best ones are admitted, to recruit staff, and to provide inspiration to the next generation of artists. The system of monthly Visitors is no longer in operation, but there are still Professors of Painting, Sculpture, Architecture, and now Drawing, as well as a Professor of Anatomy, whose duty it is to give occasional lectures.

The Royal Academy Schools continue to operate and, indeed, now accept considerably fewer students than they did in 1769. Architecture is no longer taught, nor is there the same discipline of study from the antique, followed by study of the living model. But there is still a drawing studio where it is possible to see the traditions of the eighteenth-century study of the antique, owing to the presence of innumerable casts; of anatomy, with a number of skeletons in the cupboards; and of the living model, owing to the platform upon which a model can pose in front of students, who sit, as they did in the eighteenth century, on a broad semicircle of hard benches.

The Summer Exhibition still operates in a democratic way that closely resembles the arrangements when it was first established. A committee selects works from those submitted and hangs them. While making the selection, committee members drink beef tea, whose recipe is known only to the red-collared servants of the Academy. It is extremely intoxicating. There is an annual dinner to which the great and the good are invited, among them dealers, collectors, grandees and an occasional smattering of royalty.

Perhaps most importantly, the Royal Academy still views itself as a community of the most important painters, sculptors and architects, with a small number of engravers, printmakers and draughtsmen. The number of Academicians to be admitted in each discipline was not laid out in the original Laws, but painters are still in the majority, followed by sculptors, with a slight limitation to the number of architects, for fear that they – more used to organising others in their working lives – should exercise undue sway over a society devoted, above all, to the supremacy of the pictorial arts. There is still a tension between those who believe in the importance of the Royal Academy as a club and those who think it has a more public function as the representative organisation for artists in Britain, improving the practice of the arts in this country through teaching, discussion and debate and promoting the importance of art and its value in our society.

Most of all, the Royal Academy is eighteenth century in the rawness of the opinions of its artists. They do not all believe in the same ideas about art. They fight over their place in the Summer Exhibition, sometimes politely, but not always. They mind passionately where their works are hung, because this is a visible manifestation of their standing among their peers.

By indicating how much remains the same as in the eighteenth century I might appear to suggest that the Royal Academy is archaic or anachronistic. I do not believe this. On the contrary, the persistence of so many founding principles demonstrates the extraordinary resilience of an organisation that is capable of gradually evolving while retaining its essential characteristics, and shows the value of an institution run by artists for artists. The Royal Academy is not funded by, and thus is not subject to, the state. It is private. This allows artists to run their own society as they want to in ways that are robustly independent, sometimes deeply disputatious, but disputatious because the arguments are often about important issues, a contest about attitudes to art, its quality and its practice.

The Royal Academy is democratic. But, as on the island in *Lord of the Flies*, a form of order is established, roles are defined, and someone emerges as President. It can be brutal. But at least its brutality is sanctioned by the traditions and values of the Enlightenment.

Bibliography & Sources

The early history of academies was studied in detail by Ilaria Bignamini in 'Art Institutions in London, 1689–1768: A Study of Clubs and Academies', *Walpole Society Journal*, 54, 1988, and 'The "Academy of Art" in Britain before the Foundation of the Royal Academy', in A. W. A. Boschloo et al. (eds), *Academies of Art between Renaissance and Romanticism*, *Leids Kunsthistorisch Jaarboek*, V–VI, 1986–87, pp. 434–50. An admirable and comprehensive account of the Society of Artists can be found in Matthew Hargraves, *Candidates for Fame: The Society of Artists of Great Britain, 1760–1791*, New Haven and London, 2005.

The best contemporary description of the foundation of the Royal Academy appears in the minute books of the General Assembly, which are held in the archive of the Royal Academy, alongside the minutes of Council. Together, these primary sources are probably the least prejudicial for the institution's early history. The same cannot be said for other contemporary accounts, most of whose authors had an axe to grind. The most important of these was the engraver Robert Strange, who published *An Inquiry into the Rise and Establishment of the Royal Academy of Arts* in 1775. Other contemporary sources include Thomas Jones's *Memoirs*, *Walpole Society Journal*, 32, 1946–48; Joseph Farington's *Diary*, Kenneth Garlick and Angus McIntyre (eds), 16 vols, New Haven and London, 1978–84; and Edward Edwards's *Anecdotes of Painters who have resided or been born in England; with critical remarks on their productions*, London, 1808.

The first published account of the history of the Royal Academy was written by William Sandby, descendant of two of the foundation members: *History of the Royal Academy of Arts from its foundation in 1768 to the present*, 2 vols, London, 1862. Two of my predecessors as Secretary also published authoritative histories during their period of office: Sir Walter Lamb's *The Royal Academy: A Short History of Its Foundation and Development* appeared in 1951, and Sidney C. Hutchison's *The History of the Royal Academy, 1768–1968* marked the Royal Academy's bicentenary. William Whitley included a mass of original documentation, particularly culled from newspapers, in his *Artists and Their Friends in England, 1700–1799*, 2 vols, London, 1928. Among modern writers on the Academy's history, two stand out: Holger Hoock, whose *The King's Artists: The Royal Academy of Arts and the Politics of British Culture, 1760–1840*, Oxford, 2003, was based on his Oxford D.Phil. thesis of 2000: 'The King's Artists: The Royal Academy of Arts as a National Institution, *c.* 1768–1820'; and James Fenton, the Academy's Antiquary, whose *School of Genius: A History of the Royal Academy of Arts* was commissioned by the Royal Academy and published by the institution in 2006.

These general narratives can be supplemented by a great deal of information that appears in the biographies of the leading figures involved. George III's cultural interests were analysed in John Brooke's *King George III*, London, 1972, and were the subject of an exhibition at the Queen's Gallery at Buckingham Palace in 2004, with an accompanying catalogue edited by Jane, Lady Roberts, *George III and Queen Charlotte: Patronage, Collecting and Court Taste*, London, 2004, and a book by David Watkin on the monarch's architectural interests: *The Architect King: George III and the Culture of the Enlightenment*, London, 2004. Reynolds's pocket books are preserved in the Royal Academy's archive, his letters have been edited by John Ingamells and John Edgcumbe (*The Letters of Sir Joshua Reynolds*, New Haven and London, 2000), and his pictures have been catalogued by David Mannings in *Sir Joshua Reynolds:*

A Complete Catalogue of His Paintings, 2 vols, New Haven and London, 2000. John Harris's *Sir William Chambers: Knight of the Polar Star*, London, 1970, includes a great deal of relevant material, including Chambers's unpublished autobiographical notes, as does John Harris and Michael Snodin (eds), *Sir William Chambers: Architect to George III*, New Haven and London, 1996. Benjamin West was the biographical subject of the Scottish novelist John Galt in the nineteenth century: *The Life, Studies, and Works of Benjamin West, Esq., President of the Royal Academy of London*, 2 vols, London, 1820. Among the other biographies I have drawn upon are Brian Allen's *Francis Hayman*, New Haven and London, 1987; Edward Mead Johnson's *Francis Cotes*, Oxford, 1976; and Mary Webster's definitive *Johan Zoffany*, New Haven and London, 2011.

The late Sir Ellis Waterhouse published a pioneering account of 'The First Royal Academy Exhibition, 1769' in *The Listener*, 1 June 1950, pp. 944–47; Holger Hoock wrote about the annual dinners in 'From Beefsteak to Turtle: Artists' Dinner Culture in Eighteenth-century London', *Huntington Library Quarterly*, 66, 1/2, 2003, pp. 27–54; and there is discussion of the role of Italian artists in the early Royal Academy in Shearer West, 'Xenophobia and Xenomania: Italians and the English Royal Academy', in Shearer West (ed.), *Italian Culture in Northern Europe in the Eighteenth Century*, Cambridge, 1999, pp. 116–39. In addition, it will be obvious that I have made extensive use of the invaluable *Oxford Dictionary of National Biography*, a wonderful resource for this period and exemplary in its coverage not only of the early Academicians, but also of the first generation of students.

List of Illustrations

8. Stephen Riou, *Design for the Society of Dilettanti's Academy of Painting, Architecture and Sculpture*, 1753. Ink on paper, 20 × 31.3 cm. RIBA Library Drawings and Archives Collections, London. © RIBA Library Drawings and Archives Collections

9. Sir Joshua Reynolds, *Portrait of Francis Hayman*, 1756. Oil on canvas, 76.2 × 63.5 cm. Royal Academy of Arts, London. Given by J. E. Taylor, 1837, RA 03/213. © Royal Academy of Arts, London

10. Charles Grignion after William Hogarth, *Britannia Nurturing the Fine Arts from the Fountain of Royal Munificence*, from the frontispiece to the catalogue of the exhibition of the Society of Artists, 1761. Royal Academy of Arts, London. © Royal Academy of Arts, London

11. Thomas Patch, *Caricature of Richard Dalton*, 1769. Engraving, 32.4 × 16.7 cm. The Royal Collection. Supplied by the Royal Collection Trust / © HM Queen Elizabeth II 2012

12. John Hamilton Mortimer, *A Caricature Group Including Members of the Howdalian Society*, c. 1766. Oil on canvas, 83.8 × 106.7 cm. Yale Center for British Art, Paul Mellon Collection, New Haven. © Yale Center for British Art, New Haven

13. Giuseppe Marchi, *Thomas Jones*, 1768. Oil on canvas, 92 × 72 cm. National Museum of Wales, Cardiff, NMW A 82. National Museum of Wales, Cardiff

14. Sir Joshua Reynolds, *James Paine the Elder and His Son*, 1764 (detail). Oil on canvas, 127 × 101 cm. Ashmolean Museum, University of Oxford. © Ashmolean Museum, University of Oxford

15. Thomas Gainsborough, *Portrait of Joshua Kirby*, c. 1754–6. Oil on canvas, 41.9 × 29.2 cm. Victoria and Albert Museum, London. © V&A Images

16. Attributed to Charles Grignion, *Joseph Wilton*, c. 1771. Black chalk heightened with white on blue-grey paper, 13.6 × 11.4 cm. National Portrait Gallery, London, NPG 4314. © National Portrait Gallery, London

17. Edward Penny, *Self-portrait*, 1759. Oil on canvas, 84.2 × 68.2 cm. Royal Academy of Arts, London, 03/602. © Royal Academy of Arts, London

18. William Daniell after George Dance, *Francis Milner Newton*, published 1 April 1803. Soft-ground etching, 27.1 × 19.7 cm. Royal Academy of Arts, London. Purchased from A. J. Stirling, 22 August 2000, 04/2314. © Royal Academy of Arts, London

19. Sir Joshua Reynolds, *Self-portrait as a Deaf Man*, c. 1775. Oil on canvas, 74.9 × 62.2 cm. Tate, London, N04505. © Tate, London, 2012

20. Angelica Kauffman, *Self-portrait*, c. 1770–5. Oil on canvas, 73.7 × 61 cm. National Portrait Gallery, London. © National Portrait Gallery, London

21. George Romney, *Mary Moser*, *c.* 1770–1. Oil on canvas, 76.3 × 63.2 cm.
National Portrait Gallery, London, NPG 6641.
© National Portrait Gallery, London

22. Johan Zoffany, *Portrait of Thomas Gainsborough, c.* 1772. Oil on canvas,
19.7 × 17.1 cm. Tate, London, N01487. © Tate, London, 2012

23. Jeremiah Meyer, *Self-portrait*, date unknown. Graphite on paper,
12.8 × 13 cm. Ashmolean Museum, Oxford.
© Ashmolean Museum, University of Oxford

24. Francis Cotes, *Paul Sandby*, 1761. Oil on canvas, 125.1 × 100.3 cm.
Tate, London, NO 1943. © Tate, London, 2012

25. Sir Joshua Reynolds, *Francesco Bartolozzi*, 1771–2. Oil on canvas,
76 × 63.5 cm. Saltram, The Morley Collection. Accepted in lieu of tax
by HM Treasury, and transferred to the National Trust in 1957.
© National Trust Images/Rob Matheson

26. Paul Sandby, *Dominic Serres*, 1792. Pencil and grey wash on paper,
16.5 × 12.1 cm. National Portrait Gallery, London, NPG 650a.
© National Portrait Gallery, London

27. Nathaniel Hone, *Self-portrait*, 1768. Oil on canvas, 77 × 63.8 cm.
Royal Academy of Arts, London, RA 03/211.
© Royal Academy of Arts, London

28. Nathaniel Dance, *Self-portrait, c.* 1773. Oil on canvas, 73.7 × 61 cm.
National Portrait Gallery, London, NPG 3626.
© National Portrait Gallery, London

29. William Hoare, *Self-portrait, c.* 1742. Pastel on paper, 50 × 39 cm.
Royal National Hospital for Rheumatic Diseases, Bath.
© Bath in Time – Royal National Hospital for Rheumatic Diseases

30. Anton Raphael Mengs, *Richard Wilson*, 1752. Oil on canvas, 84.6 × 75.2 cm.
National Museum of Wales, Cardiff, NMW A 113. Purchased with the
assistance of the Art Fund, 1947. © National Museum of Wales, Cardiff

31. Johan Zoffany, *Self-portrait*, 1761. Oil on canvas, 52.7 × 41.3 cm.
National Portrait Gallery, London, NPG 399.
© National Portrait Gallery, London

32. John Francis Rigaud, *Agostino Carlini, Francesco Bartolozzi and Giovanni
Battista Cipriani*, 1777. Oil on canvas, 100.3 × 125.7 cm. National Portrait
Gallery, London, NPG 3186. © National Portrait Gallery, London

33. Johan Zoffany, *Dr William Hunter Teaching Anatomy at the Royal Academy*,
c. 1772. Oil on canvas, oval: 77.5 × 103.5 cm. Royal College of Physicians,
London. © Royal College of Physicians, London

34. Thomas Banks, *John Malin*, *c.* 1768–69. Black and red chalk heightened with white on laid paper on canvas, 48.5 × 37 cm. Royal Academy of Arts, London, 04/3423. © Royal Academy of Arts, London

35. The Roll of Obligation (detail). Photograph © Phil Sayer

36. Elias Martin, *The Cast Room at the Royal Academy*, 1770. Oil on canvas, 122 × 98 cm. Royal Academy of Fine Arts, Stockholm. © Royal Academy of Fine Arts, Stockholm

37. Sir Joshua Reynolds, *Self-portrait with Glasses*, 1788. Oil on canvas, 75.1 × 63.4. The Royal Collection. Supplied by the Royal Collection Trust/ © HM Queen Elizabeth II 2012

38. Ozias Humphry, *Edward Edwards*, date unknown. Black chalk heightened with white on blue paper, 39.8 × 31 cm. British Museum, London, 1906,1103.2. © The Trustees of the British Museum

39. Ozias Humphry, *Joseph Strutt*, 1791–7. Pastel on paper, 49.5 × 43.2 cm. National Portrait Gallery, London, NPG 323. © National Portrait Gallery, London

40. Pierre-Etienne Falconet, *Self-portrait*, 1770. Oil on canvas, oval: 72 × 59.5 cm. Musée des Beaux-Arts, Nancy. © Musée des Beaux-Arts, Nancy

41. James Nixon, *Joseph Farington*, 1765. Watercolour and bodycolour on ivory, oval: 5.7 × 4.4 cm. National Portrait Gallery, London, NPG 6306. © National Portrait Gallery, London

42. James Barry, *James Barry, Dominique Lefevre, James Paine the Younger*, 1767. Oil on canvas, 60.5 × 50 cm. National Portrait Gallery, London, NPG 213. © National Portrait Gallery, London

43. Richard Earlom after Michel Vincent 'Charles' Brandoin, *The Exhibition at the Royal Academy in Pall Mall, 1771*, 1772. Mezzotint, 47.2 × 56.6 cm. Royal Academy of Arts, London, 03/4350. © Royal Academy of Arts, London

44. Agostino Carlini, *Model for an Equestrian Statue of King George III*, 1769. Gilded plaster with metal and string bridle, 87.6 × 38.1 × 59.7 cm. Royal Academy of Arts, London. Given by the artist, 1781. 03/1684. © Royal Academy of Arts, London

45. Benjamin West, *The Departure of Regulus from Rome*, 1769. Oil on canvas, 225.4 × 307.2 cm. The Royal Collection. Supplied by the Royal Collection Trust/ © HM Queen Elizabeth II 2012

46. George Michael Moser, *Design for the Headpiece of the Royal Academy Diploma*, 1769. Pen and ink with wash and white gouache on laid paper, 19 × 32 cm. Royal Academy of Arts, London, 09/1574. © Royal Academy of Arts, London

47. Giovanni Battista Cipriani, *Design for the Headpiece of the Royal Academy Diploma*, 1769. Pen and ink with wash on laid paper, 63.3 × 45.2 cm. Royal Academy of Arts, London, 03/1601.
© Royal Academy of Arts, London

48. Paul Sandby, *View from the Gardens of Somerset House looking East, c.* 1760. Pen and grey and black ink, with watercolour, over graphite; on four pieces of conjoined paper, 48.3 × 195.1 cm. British Museum, London, Department of Prints and Drawings. Bequeathed by John Charles Crowle. © The Trustees of the British Museum

49. Johan Zoffany, *The Portraits of the Academicians of the Royal Academy*, 1770–2. Oil on canvas, 100.7 × 147.3 cm. The Royal Collection. Supplied by the Royal Collection Trust / © HM Queen Elizabeth II, 2012

50. Thomas Rowlandson, *A Bench of Artists*, 1776. Pen and ink and pencil on paper, 27.2 × 54.8 cm. Tate, London, T08142. Purchased as part of the Oppé Collection with assistance from the National Lottery through the Heritage Lottery Fund, 1996. © Tate, London, 2012

51. John Flaxman, *Self-portrait at the Age of Twenty-four*, 1779. Pen and ink with some flesh tinting on paper, 18.1 × 18.7 cm. UCL Art Museum, London. © UCL Art Museum, University College, London

52. John Francis Rigaud, *Sir William Chambers, Joseph Wilton, Sir Joshua Reynolds*, 1782. Oil on canvas, 118.1 × 143.5 cm. National Portrait Gallery, London, NPG 987. © National Portrait Gallery, London

Index of Names & Places

All references are to page numbers; those in *italic type* indicate illustrations. Place names and institutions, societies and clubs are in London unless otherwise stated.